WHAT

HILLS &
MOUNTAINS
IN WATERCOLOUR

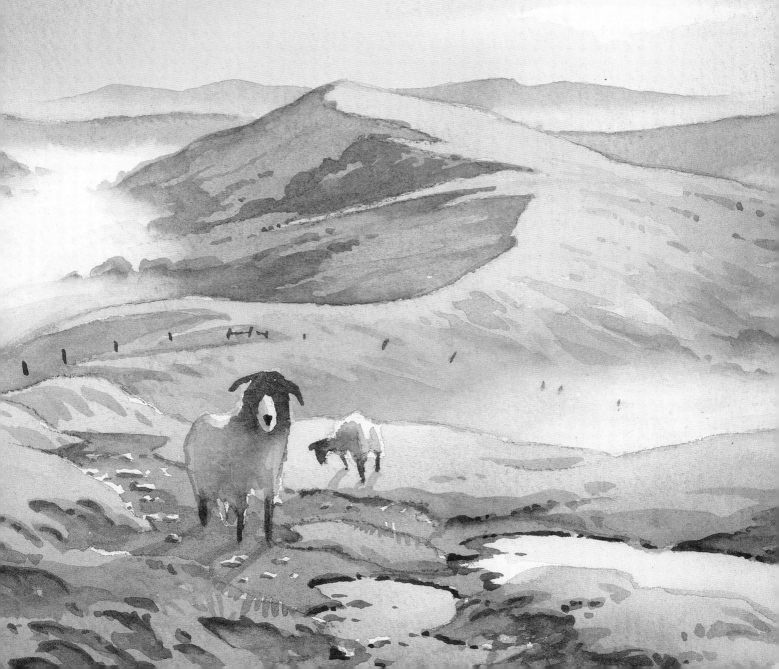

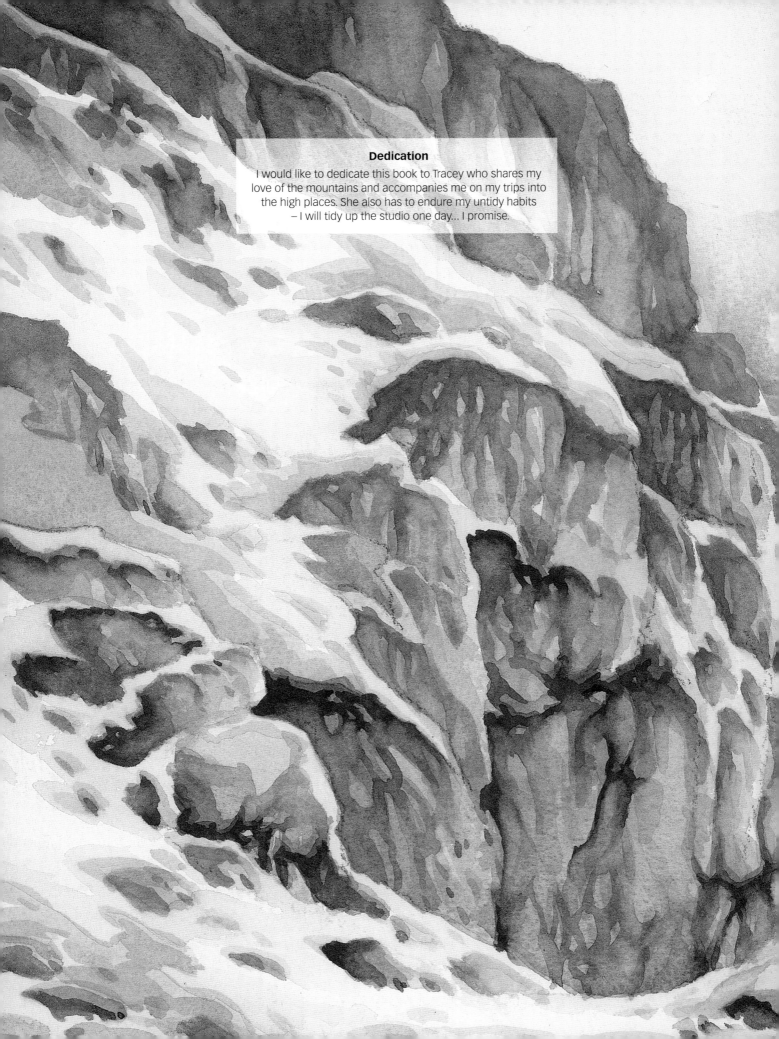

Dedication

I would like to dedicate this book to Tracey who shares my love of the mountains and accompanies me on my trips into the high places. She also has to endure my untidy habits – I will tidy up the studio one day... I promise.

WHAT **TO** PAINT

HILLS & MOUNTAINS
IN WATERCOLOUR

Peter Woolley

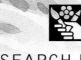

SEARCH PRESS

First published in 2015

Search Press Limited
Wellwood, North Farm Road,
Tunbridge Wells, Kent TN2 3DR

Text copyright © Peter Woolley 2015

Photographs by Paul Bricknell, Search Press Studios

Photographs and design copyright © Search Press Ltd 2015

ISBN: 978-1-78221-089-4

The Publishers and author can accept no
responsibility for any consequences arising from the
information, advice or instructions given in
this publication.

Printed in China

Suppliers
If you have any difficulty obtaining any of the
materials and equipment mentioned in this book,
please visit the Search Press website:
www.searchpress.com

Acknowledgements
I would like to thank all the team at Search Press – Daniel Conway
for editorial support and Marrianne Miall for design input as well as
everyone else who has made the book possible, and for giving me
the opportunity to share my love of painting hills and mountains.

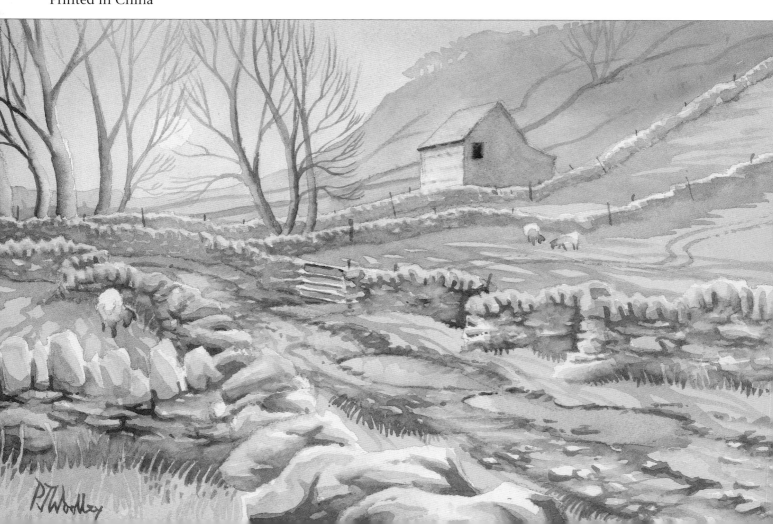

CONTENTS

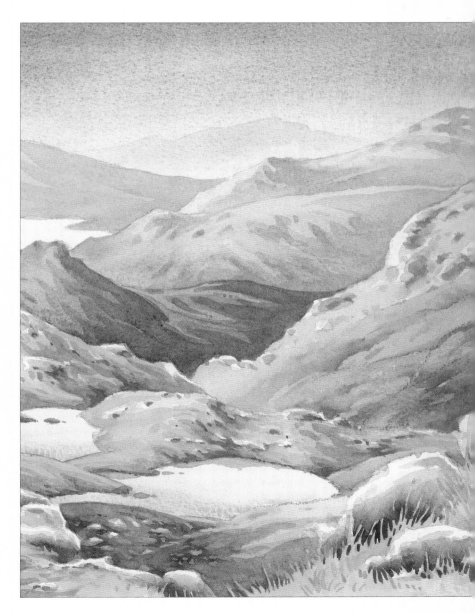

INTRODUCTION

Hills and mountains are some of my favourite subjects for painting. As a keen walker, I spend many long and happy hours out in the countryside in search of raw material, sketching and photographing potential subjects.

In wilder regions, mountains are ominous and ever-present; often majestic, sometimes sombre and threatening, but always dramatic and offering a wide variety of different moods. While trees and rivers may punctuate a landscape, it is the hills that provide the very foundation upon which they grow and from where they flow, influencing everything you see in the landscape.

Sometimes these subjects can be dark and forbidding, at other times they are full of colour; heather and bracken clothe their slopes, offering the artist a huge tapestry of emotions to draw from. The expansive hills and dales of the Peak District in the UK, which is where I am originally from, and the Yorkshire Dales, where I now reside and work, are matched only by the fells of the Lake District and the higher, mountainous regions of North Wales and Scotland. Wherever you go in the world, hills and mountains make their presence known.

In this book, I would like to present to you a selection of my favourite high places, and offer some useful techniques on how to capture them in watercolour.

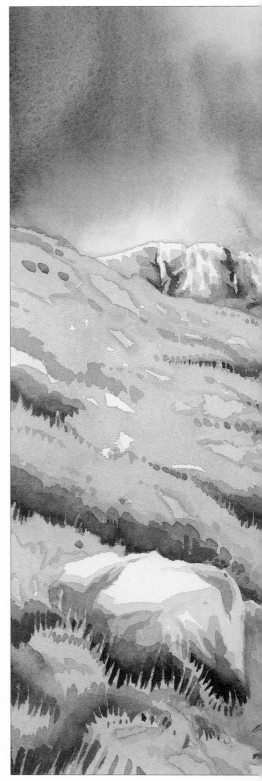

Scales Tarn, Blencathra, the Lake District, UK
From a high viewpoint such as this, the world takes on a completely different perspective. The main challenge for the watercolour artist is creating the illusion of space and depth on a two-dimensional surface. Contours explain the shape of the hills, but a change in colour and tone also helps to reinforce that sense of space.

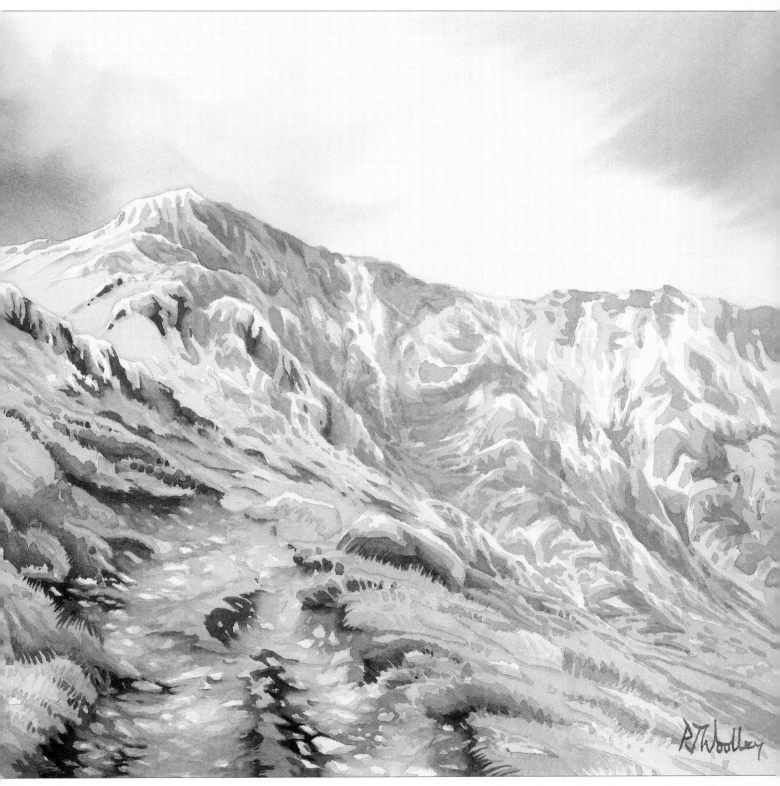

Halls Fell, Blencathra, the Lake District, UK

Mountains are rarely straightforward objects. Their many complex surfaces serve to tell the story of their formation that started many millions of years ago and continues to change right up to the present day. The undulating rolls of rock form crevasses and crags that never repeat themselves; every natural sculpture is unique and beautiful in its own right. It is this endless combination of features that never ceases to arouse the artist within.

THE PAINTINGS

Each painting is printed in landscape, full-size and at a 90 degree angle so that it fits on to one page.

Tonal Landscape, page 16

Mountain Mist, page 18

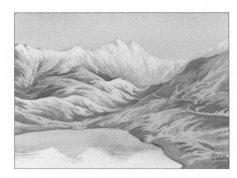

Snowy Peaks, page 20

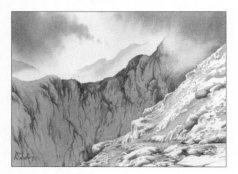

Heads in the Clouds, page 22

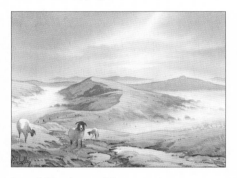

Sea of Cloud, page 24

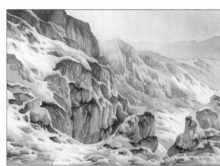

Winter Crags, page 26

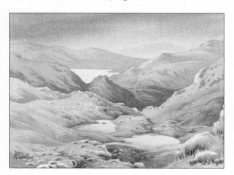

The View from the Summit, page 28

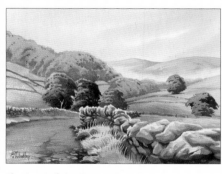

The Last of the Sun, page 30

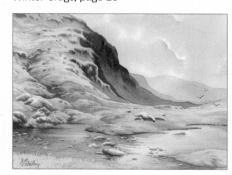

Across the Water, page 32

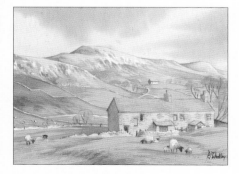

Farm in the Valley, page 34

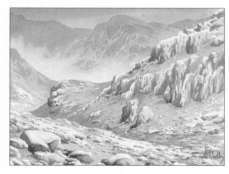

Rocks and Scree, page 36

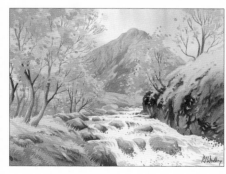

Mountain Stream, page 38

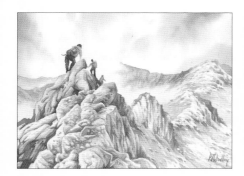

Traversing the Ridge, page 40

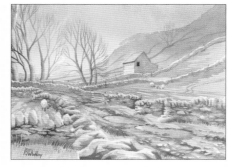

Sunset: Best Time of Day, page 42

Hill Farm, page 44

Stone Walls in the Hills, page 46

Fields and Terraces, page 48

Snow and Shadows, page 50

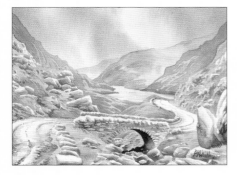

The Illusion of Space, page 52

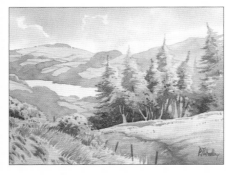

Wooded Hills, page 54

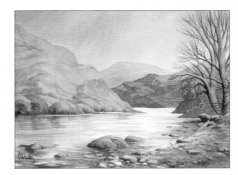

Hills and Lakes, page 56

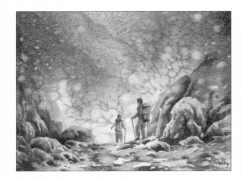

The Weather in the Hills, page 58

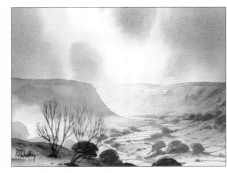

Sunshine and Rain, page 60

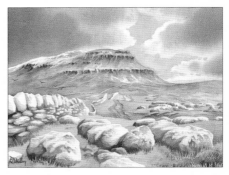

Iconic Peak, page 62

TRANSFERRING THE IMAGE

You do not need to remove the outlines from the book to transfer them on to watercolour paper if you follow the methods shown below. You can also photocopy or scan the outlines, enlarge them to the size you want and then transfer them as shown.

Using tracedown paper

This is an easily available paper for transferring images, sometimes known as graphite paper, and is similar to the carbon paper that was used in the days of typewriters.

1. Slip your sheet of watercolour paper directly under the outline you want to use.

2. Slip a sheet of tracedown paper between the outline and the watercolour paper. Go over the lines using a burnisher.

3. Remove the tracedown paper and lift up the outline to reveal the image transferred on to your watercolour paper, ready for you to begin painting.

Using pencil

1. Turn to the back of the outline you want to transfer. Scribble over the back with a soft pencil.

2. Turn the page so that you are looking at the image you want to transfer. Place your watercolour paper underneath the page. Go over the lines with a burnisher.

3. Lift the page to reveal the image transferred on to your watercolour paper. When you remove the watercolour paper, make sure you put a piece of scrap paper in between this outline and the next to avoid graphite from the back of the page transferring on to the next outline.

TRANSPARENT WASHES

Overlaying transparent washes is an efficient way of building up colour and tone. Each of the layers contributes to the overall composition, creating depth, also known as 'aerial perspective'. All paintings, no matter how complex, can be broken down into a series of washes and brush-marks varying in size, intensity, transparency and opacity – the basic building blocks of watercolour.

In *Basic washes 1* a loose wet-in-wet wash, consisting of cadmium yellow, cadmium red and French ultramarine, has been applied to set the warm, dramatic mood of the scene. In *Basic washes 2*, subsequent transparent washes of French ultramarine have been overlaid to create the mountains. The result is that distant objects appear lighter in tone and cooler in colour while nearer objects appear warmer and more intense, creating the illusion of depth.

It is essential to keep your washes light enough to allow previous washes to show through. Watercolour is a transparent medium, so we should seek to exploit that property. Also, it is important to have the utmost respect for the white of the paper, since this is where all our light comes from. Think of it as a backlight; if you apply your paint too heavily, then you are not allowing that backlight to show through. One question I am often asked is 'Why are my paintings going muddy?' Usually, the answer is that the paint has been applied too thickly, and consequently it is not allowing backlight to show through.

Also, notice how I have been careful that the subsequent wash has been kept within the bounds of the earlier wash. When adding a new layer, I have used exactly the same French ultramarine mix, until the final wash, which has been intensified by adding more pigment and mixing in a small amount of burnt umber to tone it down.

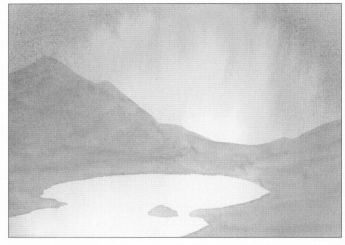
Basic washes 1

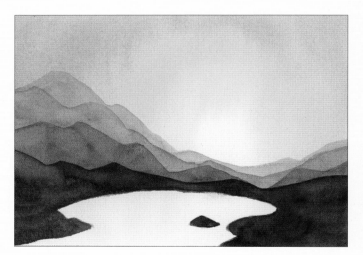
Basic washes 2

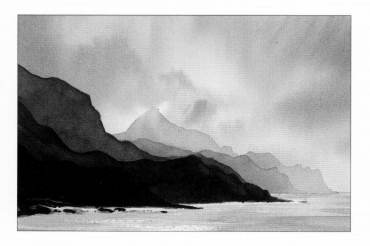

Mindelo, Cape Verde Islands

The same principle has been applied to this painting I produced of Mindelo, in the Cape Verde Islands. However, instead of French ultramarine I used a much warmer mix of cadmium yellow and cadmium red, gradually darkening the mix by adding French ultramarine, burnt umber and alizarin crimson. This same scene could have been produced very differently by drawing in the mountains and mixing different colours for each segment. The result would not be nearly as coherent, or harmonious.

COUNTERCHANGE

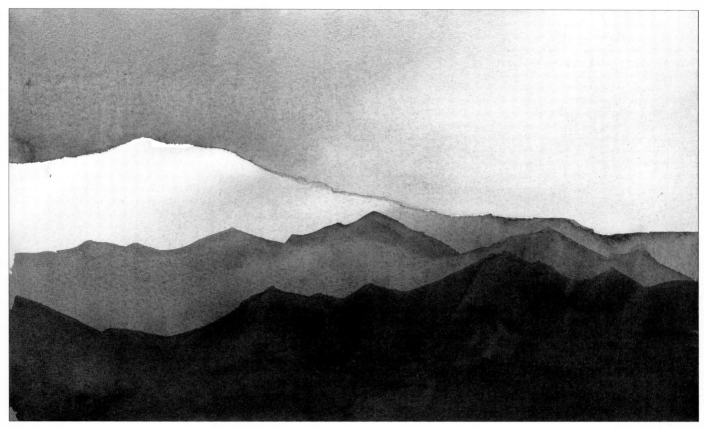

Counterchange example

Counterchange is a phenomenon of tonal contrast that can be observed in many different circumstances, but it is of particular importance when painting distant hills and mountains.

In this composition, note how the sky graduates from a dark tone to a lighter tone from left to right, while the line of hills below it graduates in a similar way, but in the opposite direction; this is an example of counterchange.

To paint this, I started by drawing the line of the furthest hill first and, ignoring the nearer hills, I then applied a graduated wash to the sky, using French ultramarine. To get an even, smooth gradation, it is often easier to turn your painting board onto its side to encourage the paint to flow more easily. When the wash had dried, I turned my board in the opposite direction and repeated the process for the hills.

It is important to try to bring both washes as closely together as possible without overlapping. If washes overlap, then the result will be a dark line.

The two nearer layers of hills were applied after each subsequent wash had thoroughly dried, each time adding more French ultramarine and a touch of burnt umber.

Look out for instances of counterchange in the paintings that follow. The first painting, *Tonal Landscape*, relies almost entirely upon counterchange since it has been painted using only one colour. All the other paintings have counterchange as well, though not always so noticeably.

HOW TO PAINT ROCKS

When painting hills or mountains, it is common to come across rocks. Sometimes, there will be just the odd boulder at the foot of a peak, broken away, or left from the effects of glaciation, or there might be a whole hillside full of them; scree slopes, or landslides, for instance.

Painting rocks can seem problematic; I am often asked by students and visitors at art shows, what techniques I use to create them. Put simply, we have to think in three-dimensional terms. Rocks are more than a single two-dimensional object, so we have to create the illusion of depth by visually explaining each of their surfaces; what I like to call 'virtual sculpting'.

After drawing the outer shape with a 2B pencil, paint the rock using a light grey mixed from French ultramarine and burnt umber. Try to get it as even as possible, but do not worry if it is not completely even; any little blemishes, hard lines or backruns will simply add to the texture.

Along the bottom edge of the rock, flick the brush downwards in a random movement to create blades of grass. This is 'negative painting' – the spaces between the brushstrokes represent the grass and the brushstrokes themselves represent the spaces between the blades of grass. Allow to dry before beginning the next stage.

Left as it is, the rock looks flat and two-dimensional. So, add another layer of grey – the same mix, only slightly richer. Suddenly, it is no longer a flat shape – adding a new layer like this has given it the illusion of having two surfaces: the light, top surface, and a slightly darker surface that is facing us.

We have to be careful not to make the new layer too geometrical. Each time we apply a new brushstroke, it is like chipping away at the rock – this is like virtual sculpting.

Continuing this process of sculpting, another chunk of the rock can be chipped away simply by applying a new wash. (Notice how I am continuing to repeat the negative painting along the bottom edge of the rock, to maintain the illusion of grass.)

It is important for this new shape not to be an exact replica of the previous one. It is also important, though, at this stage, for it to be kept within the bounds of the lighter tone.

The rock now has three surfaces, represented by the three shades of grey. For rocks to look natural, the shape must have a random and natural appearance. They must look as though they arrived at this form through years of erosion. Each application must stay within the boundary of the previous wash, and you must try to avoid repetition wherever possible.

Although you should avoid repeating patterns from the previous washes, that is not to say that you should not be guided by them. There is clearly a bit of a gully on the side of this rock, which I have used as a guide – ultimately, I am thinking, this should have a crack in it.

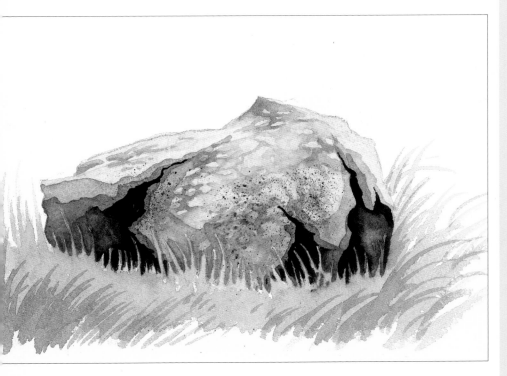

Finally, the texture of the rock needs to be roughed up. Unless we want our rock to be totally smooth, there will be all manner of varying textures and contouring on the surface.

One way to suggest this is to use some of the lighter grey and paint in details directly, then soften the brushmarks off with a damp brush, to blend them into the surrounding wash.

Another great way to create random texture is to spatter paint at the paper. Take care as this can be a messy process, but its unpredictable nature is perfect for the job.

Complete the painting by adding some green to the grass. I have mixed mine from cadmium yellow and Prussian blue.

TONAL LANDSCAPE

Let us start with a simple, but important, observation: while colours are, of course, crucial to the telling of a visual story, an understanding of tonal values and, more specifically, contrasting tonal values is essential to create a good, strong composition.

One of the best ways to learn about tone is to paint a picture using a single colour; what might be called a 'tonal study'.

This is painting is a view from the top of Grindsbrook, on Kinder Scout in the Northern Peak District painted using only Payne's gray. It is visually coherent because there are sufficient contrasting tones strategically placed throughout the scene to make it understandable.

PALETTE OF COLOURS

Payne's gray

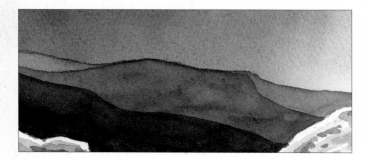

Here, I have overlaid a series of three washes. These variations in tone create a sense of distance and space. This creates aerial perspective as the more distant hills, which are lighter, seem further away, while the darker hill seems closer.

Traditionally, sepia is a popular colour to use, but I have always favoured Payne's gray. Whatever colour you choose, it should have a broad tonal range, so that you can produce intensely dark tones such as this slope, but also water it right down to produce light, delicate tones. A broad tonal range means there are lots of tones to choose from between the two outer extremes.

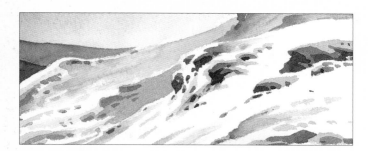

Using only a single colour, I have kept some of the darkest tones of the composition so that they contrast starkly against the white of the snow. The lighter we want something to appear, the darker the adjacent tone needs to be. Creating this contrast allows the rocks that are nearer to us to have more of an impact. It is also worth noticing that the distant rocks are painted using only one tone, while the nearer ones are broken down into three tones. In this way we can effectively push distant objects back and make them less likely to compete with the foreground.

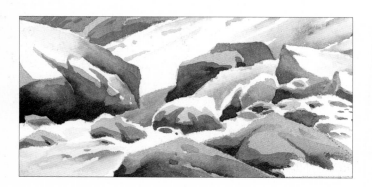

As the painting developed, I monitored the tonal values of each and every rock, to make sure that good, solid contrasts were maintained throughout. The result is clear definition between the individual objects. For instance; if you look closely at the large rock on the left here, you will see that I graduated the top portion of it from left to right, subtly changing it from a light tone to a dark tone. If the rock was left as an even, light tone over its whole width, then it would merge into the light tone of the hill behind it. By varying the tone in this way, one can achieve counterchange, contrasting dark against light. The same principle has been applied to every single rock in the foreground.

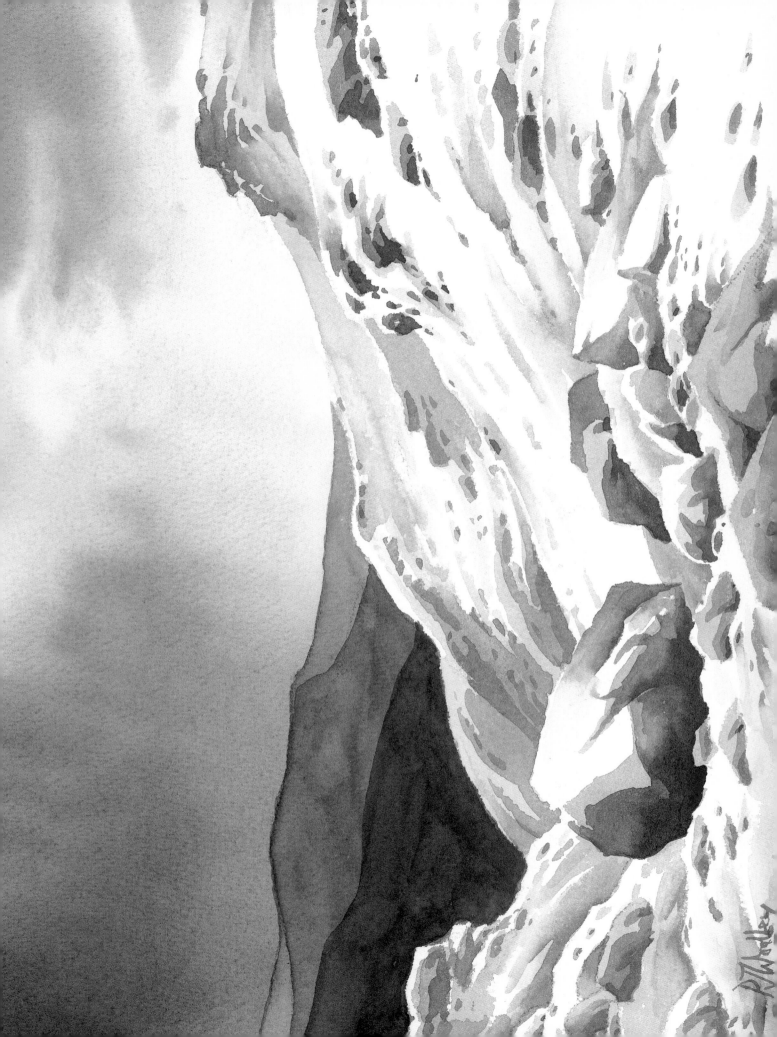

MOUNTAIN MIST

Grasmere is one of my favourite walking/sketching destinations in the Lake District, UK. It is easy to see how the same location inspired the likes of William Wordsworth and Samuel Taylor Coleridge.

Whether through poetry or painting, the Lake District offers a little bit of everything for the artist. However, the sweeping Cumbrian landscape can be daunting at first and the wealth of visual information contained within it needs to be filtered out, and whittled down. Total beginners to the medium of watercolour might rightly ask 'Where should I start?'. The answer is not as complicated as you might think.

PALETTE OF COLOURS

- Cadmium yellow
- Cadmium red
- French ultramarine
- Burnt umber
- Alizarin crimson

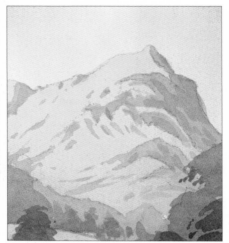

Always start by reducing the subject down to smaller, manageable forms. In this example, I have reduced Helm Crag (the pointy bit at the very top) to a very simple structure by only using a few washes overlaid on top of each other. An initial, light wash (mixed from cadmium yellow and cadmium red) establishes its overall, outer shape, while subsequent washes, of increasing intensity, break that shape down, and do the job of explaining a few, carefully selected contours. It can be tricky to achieve a believable result, and care needs to be taken to make the contours look as convincing as possible. It pays to study the subject as thoroughly as you can so that you understand its surface and be sure not to rush it (something I see students do all too frequently).

Try to avoid including too many fine details here in the distance which could compete with the foreground details of the final composition.

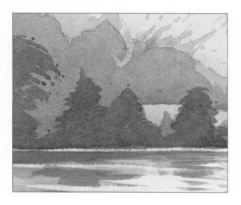

Remember to work from light to dark. The trees have been built up in layers to increase their intensity and create aerial perspective (a sense of depth). The darker the tone of the trees, the nearer they appear to be.

Note:
Avoid too much repetition of shapes. Nature creates, and arranges, objects randomly. Seek to replicate this as much as possible in your work.

I have created the illusion of mist by softening off the base of the hillside with a damp brush. Sometimes referred to as 'lost-and-found edges', this technique is a subtle way to introduce mystery, and mood, into a scene. It is often not what we see, but what we do not see, that makes a scene visually interesting to us. Our brush-marks may explain the basic layout, but leaving a little something to the viewer's imagination is always a good thing. The trick is to offer a damp brush up to the edge of the shape you wish to soften off, encouraging the paint to flow into it. Lightly dabbing it with a piece of tissue will also prevent hard lines from appearing. It is important to use a damp and not a wet brush, otherwise the moisture will be more likely to flow in the opposite direction, and create a backrun (sometimes referred to as a 'bleed-back', which is to be avoided at all costs).

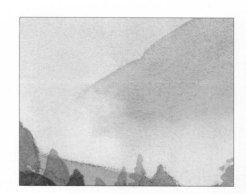

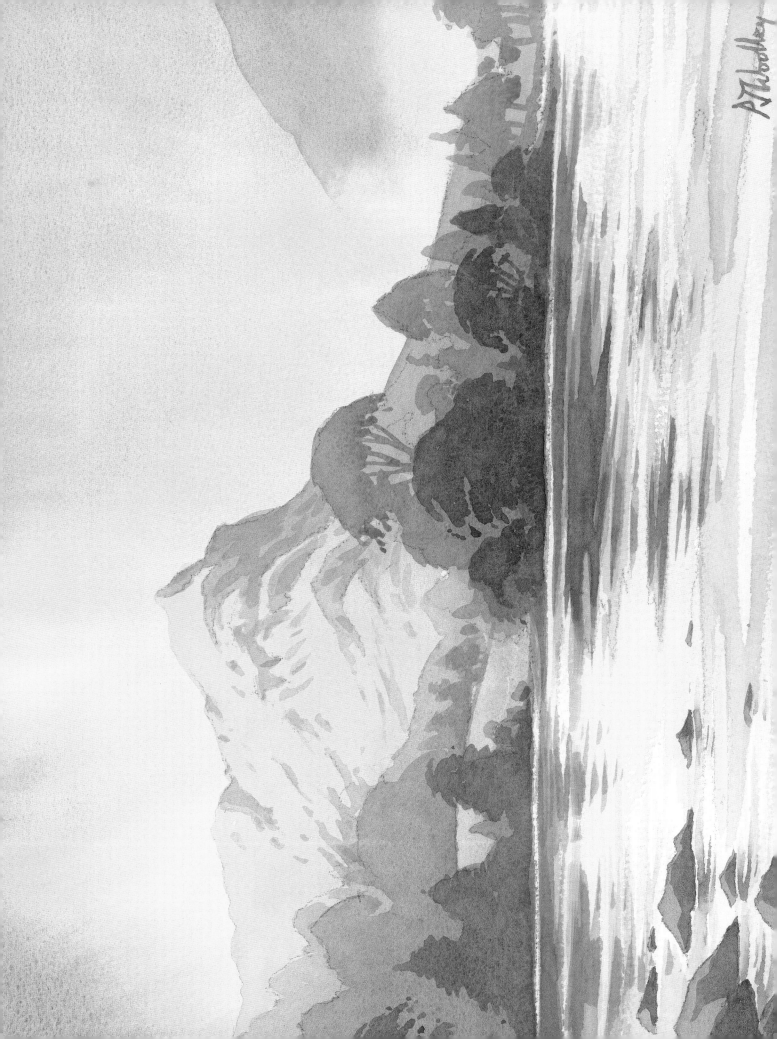

SNOWY PEAKS

I love to see mountains and hills in the snow. In these conditions, they are reduced to simple but dramatic forms, accentuated by tonal contrasts.

This scene was painted after a trip to Snowdonia in Wales, UK, when only a small amount of snow actually remained on the highest peaks. It was enough to plant the seed of an idea in my mind; as an artist, it is perfectly acceptable to accentuate, modify or omit any elements of a scene if one feels it is likely to improve the composition or reinforce a particular mood that one wishes to convey.

Here, my aim was to convey a scene of quiet reflection. I have deliberately tried to juxtapose the cool of the snowy mountains with the warm evening light.

OUTLINE
3

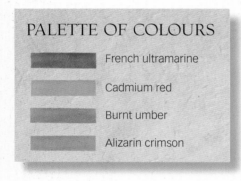

PALETTE OF COLOURS

French ultramarine

Cadmium red

Burnt umber

Alizarin crimson

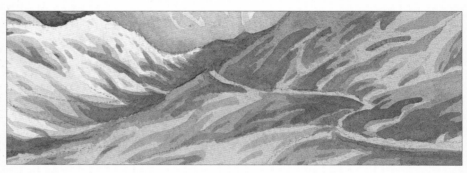

This scene relies on shadows to convey the three-dimensional shape of the objects within it. Without shadows of any kind, snow simply looks flat and two-dimensional.

Mountains fascinate me for many reasons and I will often pause to gaze across at the undulations of the landscape. When your brain becomes accustomed to the view, what might at first have appeared as a simple landscape starts to become more nuanced, as interesting features and variations are revealed. As a watercolour artist, you should seek to accentuate these little nuances.

Here, I have used variation in tone to explain the contours: the shadows, mixed from French ultramarine, burnt umber and alizarin crimson, follow the changes in the ground. Making some of those shadows slightly darker than others, makes them stand out a little more from their surroundings.

To help maintain a sense of tranquillity, I have kept the detail in the water to a minimum. The reflections of the hills should at least vaguely match up to the rise and fall of the hills themselves, although absolute accuracy is not always necessary.

The gentle movement of ripples on the surface of the water is suggested by breaking up the reflections along their bottom edges. How broken up those reflections are will explain how turbulent the water is; we do not want to overdo such details, or it could have an adverse effect on the calmness of the scene.

The white of the snow reflects and absorbs much of the colour from its surroundings. To prevent my hillside from being too glaringly bright, I painted an initial wet-in-wet wash of French ultramarine and cadmium red over it, and lifted it out with tissue instead of painting around it. By doing this, you ensure that a small amount of the initial colour remains on the surface; not much, but just enough to take the glare off.

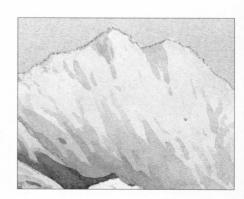

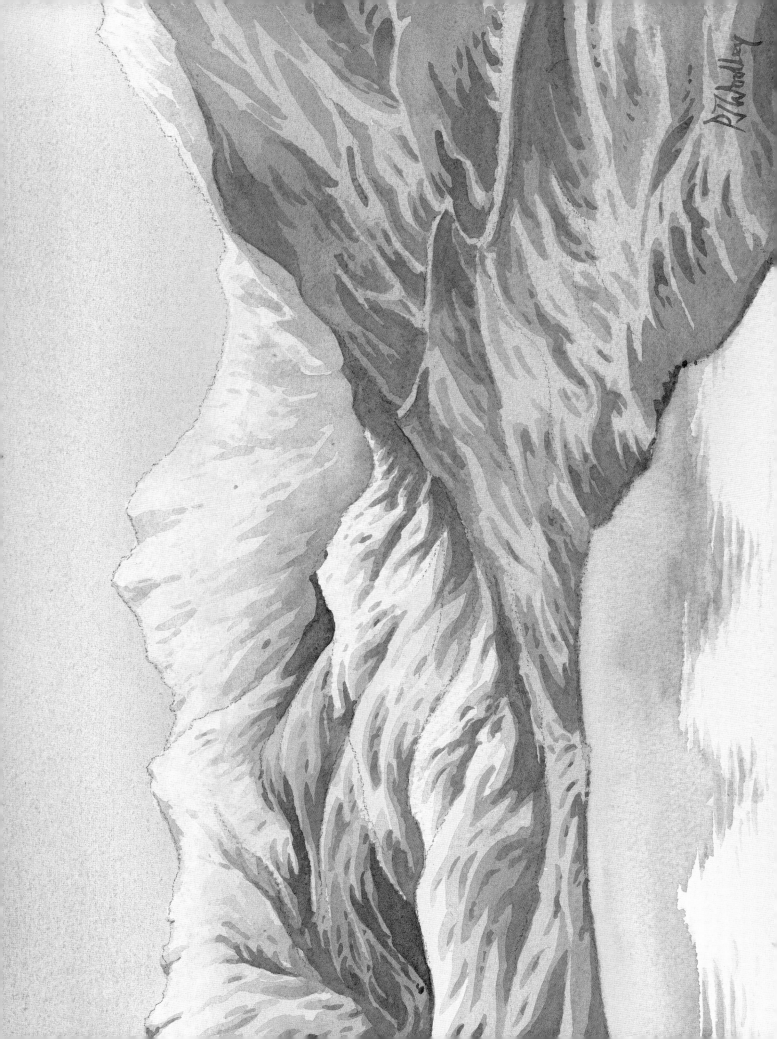

HEADS IN THE CLOUDS

There are many routes up to the top of Snowdon, the highest and probably most famous mountain in Wales. Whichever route the visitor chooses, the summit constantly looms high ahead, often hidden by low scudding clouds and occasionally making an appearance before disappearing into the gloom once again. This, for me, is when mountains are at their most dramatic.

Paintings that refrain from revealing everything can become more attractive to the viewer. A scene that raises a few questions can be far more interesting than one that lays everything out in plain view. So, do not feel you have to attempt to capture every detail; instead, try leaving some things to the imagination.

PALETTE OF COLOURS

French ultramarine

Burnt umber

Alizarin crimson

Cadmium yellow

Prussian blue

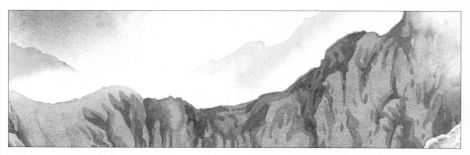

Mountain peaks have a habit of disappearing when the weather comes down. Crags can be there one minute and gone the next, disappearing with increasing frequency the higher up you climb.

The sky sets the whole mood of the scene, so it makes sense to lay it down first in a painting like this. Here, the soft greys of the clouds have been painted wet-in-wet, mixed from French ultramarine and burnt umber, and given that warm, slightly angry look by adding a small amount of alizarin crimson. After establishing the clouds, I concentrated on the hills in the middle distance, using the same warm grey mix and softening them off along the top edge, where the low cloud is hanging.

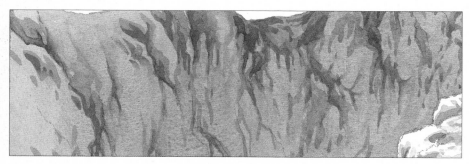

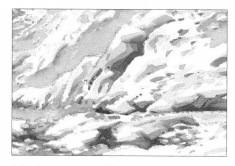

The details on the middle-distance hillside were mixed from a darker version of the same warm-grey mix as the hillside. Remember to avoid repetition of patterns; the details must look as random as possible. A few straight lines are okay, but, overall, you should try to avoid creating anything too angular or geometric in appearance. I painted in the background hills last of all, softening off the brushstrokes along their bottom edges with a damp brush to retain the illusion of low-level mist, and increasing the ambient drama of the scene. Mist and low clouds can be manipulated to suit the composition. It is a great power artists have to be able to shift such elements around at will. We can change the time of day or the weather on a whim, but be sure to use that power wisely.

It is always a good idea to reuse colours as it helps to promote harmony and cohesion in the composition. For instance, the grey in the sky can be reused for the shadows on the foreground rocks.

The green, mixed from cadmium yellow, Prussian blue and burnt umber, was added carefully to produce rocks through negative painting – in other words; the rocks were created not by painting them directly, but by painting around them.

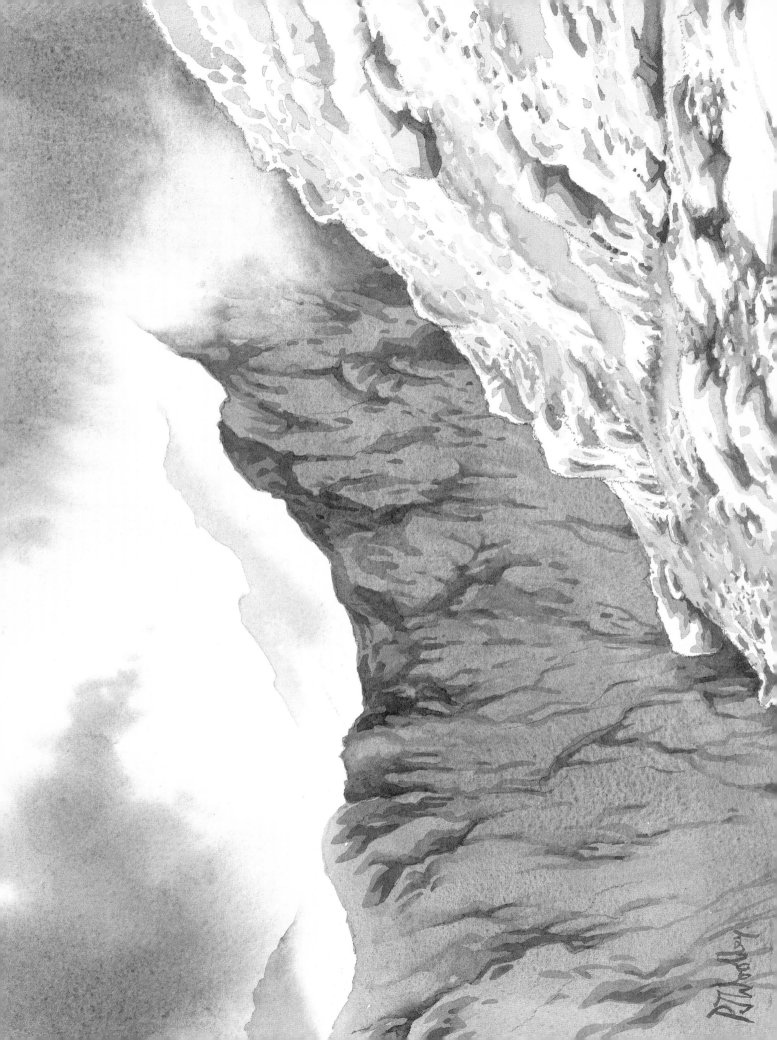

SEA OF CLOUD

The moment the sun rises can be spectacular and, after a clear night, it is often accompanied by morning fog formed when the damp ground cools the surrounding air in the valley. When the days get shorter and the mornings colder, there is a greater chance of observing these low-lying mists, which cling to the valley floor. The sun will normally destroy this effect within an hour or so of rising, so only the earliest of risers get to enjoy it. However, there are rare occasions in mountainous regions when the effect can last all day – this is known as an 'inversion aloft' created when a layer of warmer air exists between colder air above and below. If this layer dips below summit level, clouds at the top of the lower cold layer will appear as a beautiful sea of cloud from the summit.

OUTLINE
5

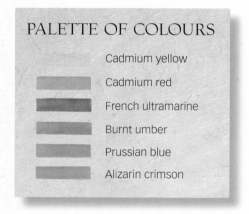

PALETTE OF COLOURS

Cadmium yellow

Cadmium red

French ultramarine

Burnt umber

Prussian blue

Alizarin crimson

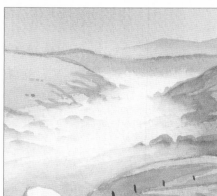

Painting such an effect is surprisingly simple. Essentially, all you need to do is paint the rising hills wet-on-dry, and constantly soften off the bottom edge with clean water on a damp brush (note: damp but not too wet). The trick is to offer clean water up to the lower edge, thus encouraging it to flow downwards into the clean, damp area. If this area is too wet, the paint will flow to the bottom of the damp area and create another hard edge, so at some point it may be necessary to lightly dab this with a tissue to diffuse and disperse it.

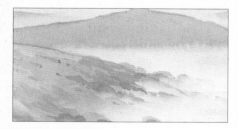

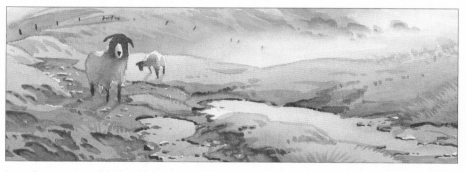

Mood and mystery are two important ingredients for a scene like this. The mood should be kept quiet, with colours that do not compete too stridently with each other (most paintings are improved by keeping the number of colours down to a minimum).

Mist provides mystery in this piece so the details of the hillside should be added carefully. If they look too rich or dark, then lightly dabbing them immediately with a piece of tissue will instantly lower their dominance and help to blend them in a little more to their surroundings.

It is worth noting that, although many details are partially hidden to us, those that are visible must still be seen to follow the contours of the ground beneath the mist.

In such a scene as this, in which much of the view is simplified, the foreground features take on a particular importance. Here, I have chosen to populate the foreground with some sheep, common to the location. They provide a focal point and a starting point for the eye to travel along the ridge known as 'The Great Ridge' in Northern Derbyshire.

The inclusion of puddles on the track in the foreground is not accidental; they provide the means, or at least the excuse, to disperse colours from the top half of the painting out into the lower portion, helping to link those areas together more coherently.

Small, random highlights have been turned into stones and rocks by simply placing a dark tone along one side of them, giving them a more three-dimensional shape. Such details also help to increase the illusion of space and distance, as long as they are kept in the foreground and not on distant objects.

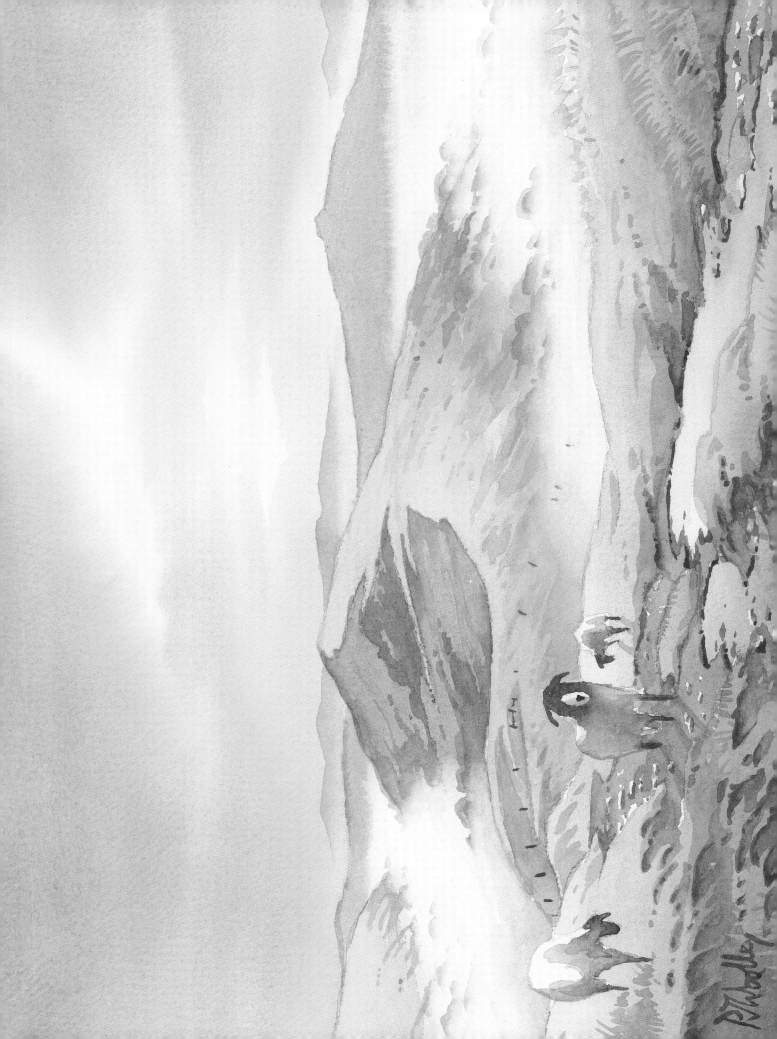

WINTER CRAGS

Thousands of years' worth of erosion from weather and glaciation ensure that no two mountain passes ever look the same. Crinkle Crags, high above the Langdale Valley in Cumbria, UK, are aptly named and illustrate this point well.

Every painting has what is known as a 'path of vision': a route the eye travels along when looking at it. Crags help to punctuate a hillside and prevent that path of vision from being too linear or, frankly, too boring. They provide drama and scale, but they also help to hold a viewer's interest long after the initial appraisal.

Crags offer us a glimpse into the very foundations of a mountain. Layers of rocky strata exposed to the elements help us to understand how it has been formed over the millennia. These are the places where the mountains really bare their souls.

OUTLINE
6

PALETTE OF COLOURS

Cadmium yellow

Cadmium red

French ultramarine

Burnt umber

Alizarin crimson

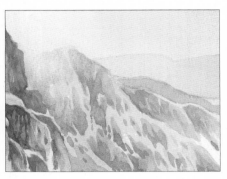

To add visual interest, I decided to flood the scene with the warm light of a late afternoon's wintry sun. To illustrate the simple power of the sky, I used a wet-in-wet wash consisting of cadmium yellow, cadmium red and French ultramarine, scrubbed out slightly at the top of the middle-distance hill to reinforce the glow factor. Those same colours were then repeated on the many highlights along the tops of the foreground rocks, dispersing the colours throughout the composition and preventing them from being too isolated in the top third of the painting.

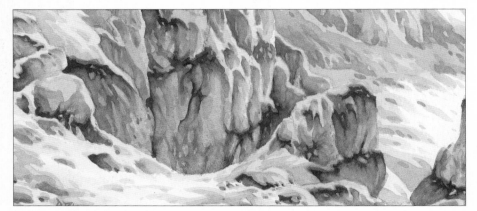

When painting rocks, always aim to create something that looks natural, without obviously repetitive geometric features. As with all watercolour painting, always work from light to dark, laying down a light grey base colour to establish the underlying look.

Apply the brushstrokes randomly with varying degrees of pressure so that large marks sit alongside small marks. A constant regime of application, softening off, and then blending in to the surrounding wash should prevent any one mark becoming too dominant. Stand back from your painting often and allow those brush-marks the space to work independently. Take your time and look for elements that have happened outside of your control. Often the unplanned elements are the best so try to capitalise on these occurrences.

The darkest tones should be carefully added last. By this stage you should be getting an inkling of where they most need to go; concentrate and be intuitive. If a dark tone does not look right the moment you apply it, then it can immediately be lifted out and rethought, although this leaves a small amount of pigment on the paper; a fact that can also be used to your advantage.

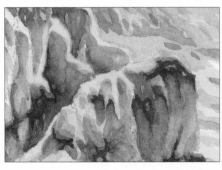

Note how important it is for the darkest tones in the background crags to be much lighter than those in the foreground. This way, the illusion of depth and space is maintained and the two areas are prevented from competing with each other.

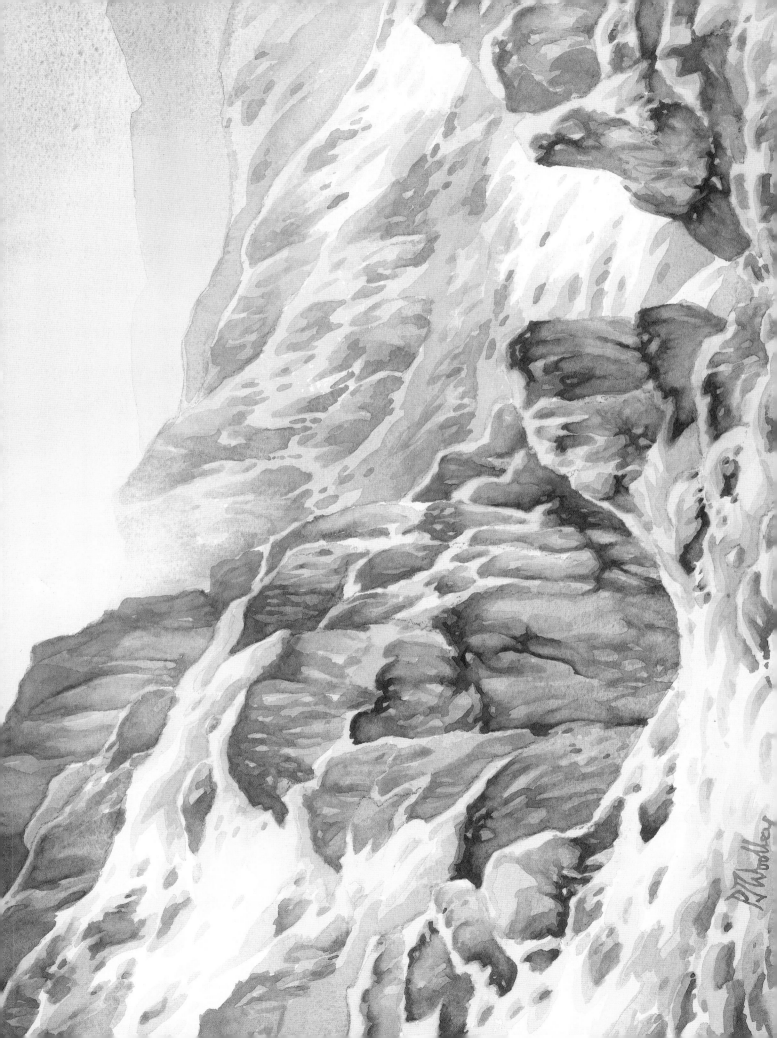

THE VIEW FROM THE SUMMIT

OUTLINE
7

I believe that hills and mountains are at their best when viewed from the highest point, which often requires a little bit of energy and determination. This is one of my favourite views of the Lake District looking across to Derwentwater, from Seathwaite Fell, as seen in a warm, evening light. What the view illustrates rather nicely is the way that all hills and mountains are very different from each other. Try to avoid falling into the trap of making all your hills in a scene look the same – always look for their individual characteristics and then try to capitalise on them.

PALETTE OF COLOURS

Cadmium yellow

Prussian blue

French ultramarine

Burnt umber

Alizarin crimson

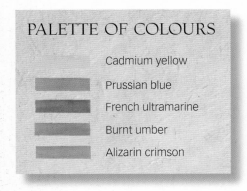

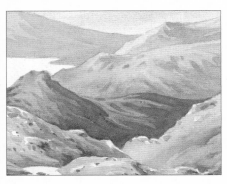

It is important that background hills do not look as though they are sitting on top of those in the foreground. One solution is to ensure that hills appear lighter in tone and cooler in colour the further away they are. In this example, compare the yellow of the nearer hill with that of the more distant hill.

It is very common in mountainous regions like this to find small, natural lakes known as 'tarns'. Visually, they help to break up the monotony of the hills and provide added interest. Notice how the changes in tone in the surrounding land and the water depict slightly different things. Tonal variations help to give the land a three-dimensional, solid quality. In the water, the change in tone appears, initially, as a reflection of the sky with the darkest blue/grey colours as reflections of the bank. It is preferable not to leave the water as a single, flat tone; doing so reduces its perceived reflectiveness. Leaving it white would result in it looking like a patch of snow.

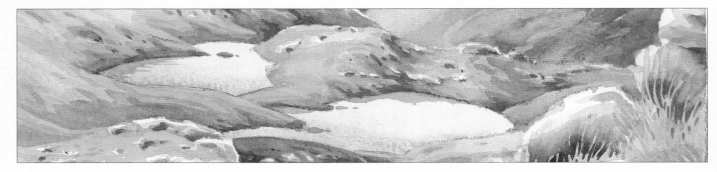

The grass in the foreground was created using a negative painting technique. The darker tone of the rocks is flicked into the light green of the grass; the spaces between those flicked brushstrokes represent the individual blades of grass. It is a tricky technique to master, but one that can be very handy, and it becomes easier with practice. The biggest challenge is in avoiding repetition of shapes, and maintaining a slightly curved grass-like look. An alternative method would be to apply masking fluid to the grass blades, allowing you to paint the rocks freely in the knowledge that the grass is protected. There are pros and cons to both techniques, although my preference has always been towards that of negative painting. For me, it has a slightly looser, wilder finish to it (and if you accidentally paint over a blade of grass, it can often be an improvement!).

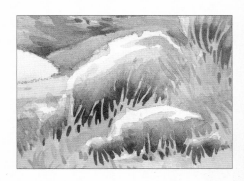

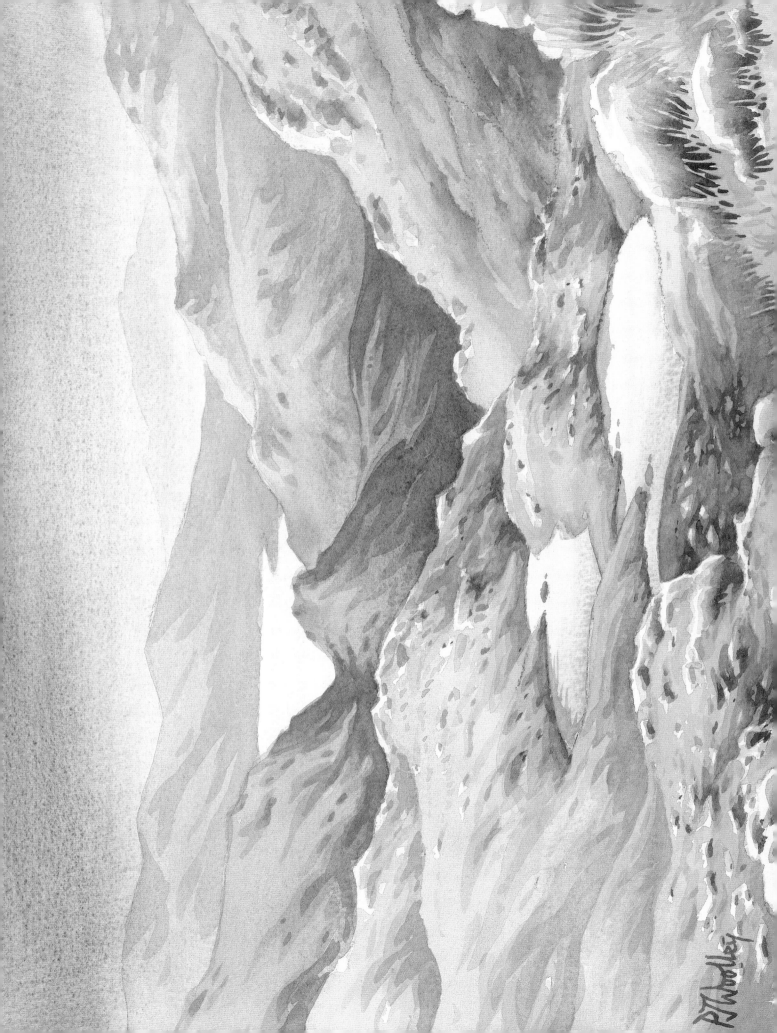

THE LAST OF THE SUN

One of the most thrilling things about watercolour is the ability to play around with light. I have always been mesmerised by the effects of light as it catches the hills either at the very start or the very end of the day. The juxtaposition of warm against cool and dark against light is irresistible. Creative lighting is an area in which risks are worth taking. Throwing all your light into one small area of a painting while keeping the rest of it in semi-darkness is not something that comes naturally to many painters, yet the rewards can be eminently satisfying. I consider it a risk worth taking.

PALETTE OF COLOURS

Cadmium yellow

Prussian blue

French ultramarine

Burnt umber

Cadmium red

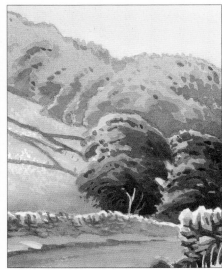

I wanted to create the impression of standing in an area of cool shadow, looking out towards a background bathed in warm sunlight. To reinforce this impression, I chose to keep my palette cool; removing greens entirely from the trees on the left-hand slope in order to enhance the contrasting warm hues of the sunlit hillside. The reason the contrast works so well is because the colour blue is directly opposite the combination of red and yellow on the colour wheel.

From a distance, a wood made up of lots of trees tends to morph into one single shape clinging to the hillside. In this sort of situation it is important not to fall into the trap of painting large numbers of individual trees, which could look too cluttered, and might compete with what is going on in the foreground.

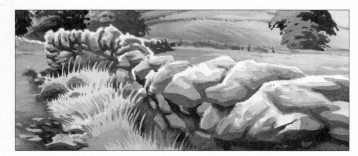

One way to approach almost anything in watercolour is to break things down into two or three clearly defined tones. In this wall, you can clearly see the stones have been reduced to a light tone, mid-tone and dark tone, with a smattering of warm, textural details to add some subtle, visual interest. For stone walls to look convincing, it is important not to make them too angular, or too geometrically repetitive; the 'less is more' approach works well too. Unless you want your wall to disappear into the scene, it is also important to leave a highlight along its top edge to maintain a contrast with its surroundings. Such a highlight does not necessarily have to remain white, though a light wash (light grey in this example), helps to reduce its luminosity and remains more in keeping with its immediate environment.

It seemed fitting that the left-hand hillside should have a touch of frost. One of the simplest and most effective methods of depicting this is to use something known as 'dry-brush technique'. This is achieved by running a partially loaded round brush across the surface of the paper, on its side. On rough paper the paint catches just the very top of the surface pattern, resulting in a broken brushstroke. Another way to create frost is by rubbing sandpaper across the surface of a wash after it has dried – I prefer the dry-brush option.

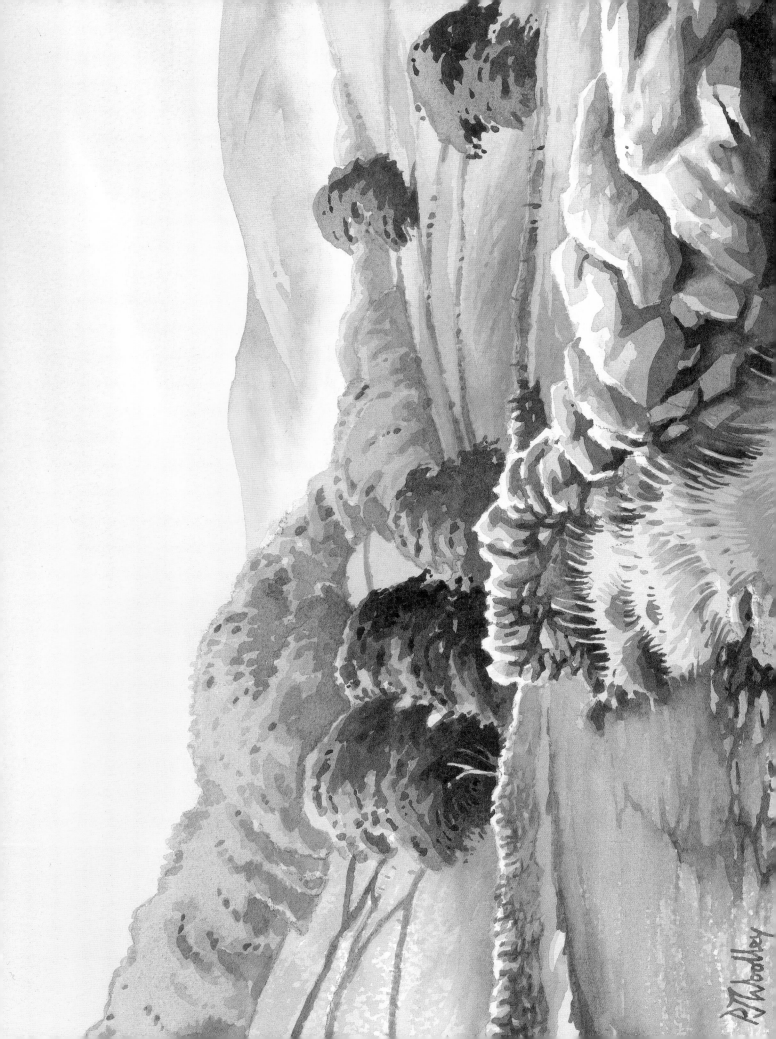

ACROSS THE WATER

If we paint a shape using a single colour and tone then it will look flat and two-dimensional. One of the biggest challenges we face in watercolour is how to create the illusion of three dimensions on a flat, two-dimensional surface. To do this we need to apply contours to our mountain shape. This is Falcon Crag, as seen from Grisedale Tarn, high in the Lake District, UK. You can see from the sky how loosely I approached the scene, concentrating most of my energies on creating realistic contours that, hopefully, explain the three-dimensional shape of the hillside.

PALETTE OF COLOURS

Cadmium yellow

Prussian blue

French ultramarine

Alizarin crimson

Burnt umber

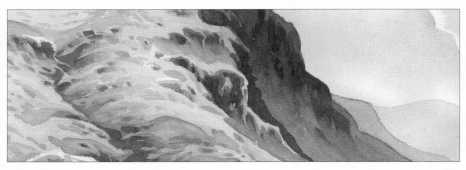

As always, it is worth taking time to try to understand the shape of the hillside before beginning. If you know, in your own mind, right from the start, where the light is coming from and how that light is likely to fall upon the land then you are far more likely to create a convincing and coherent result.

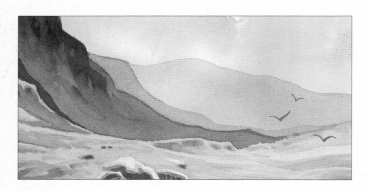

Variations in tone are critical when it comes to depicting a receding range of hills. Although the general rule of thumb is that lighter and cooler means more distant, you can see from this example how there is no hard-and-fast rule on this. My foreground is light and the next hill immediately behind it is extremely dark. Subsequent hills then graduate towards a lighter tone again. Variations in details are just as useful – reducing the amount of visible detail on distant objects helps to keep them back.

In a scene like this, it is best to keep reflections as simple as possible. It is a good idea to vary the tone and colour, in order to give it a touch of luminosity. Here, I have reflected the green from the bank nearest the water. Notice, also, how a smattering of random highlights can easily be turned into small rocks and pebbles simply by applying a dark tone to one side of them. Such stones, partially submerged as they are in the stream, help to explain how shallow the water is at that point.

There is a big visual difference between still water, fast-moving water and slow-moving water. In still water, the reflections will be clearer with only the slightest of distortion where surface winds might disturb them. Gently moving water will show reflections, but they will be affected by ripples that distort them far more than still water. Fast-running water may reflect some of the colours from above, but clear reflections will be noticeably absent because parts of the water's surface simply don't stay still for long enough. In this example, the water is moving very gently, but the bank is not reflected clearly.

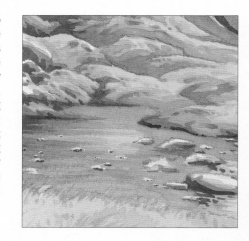

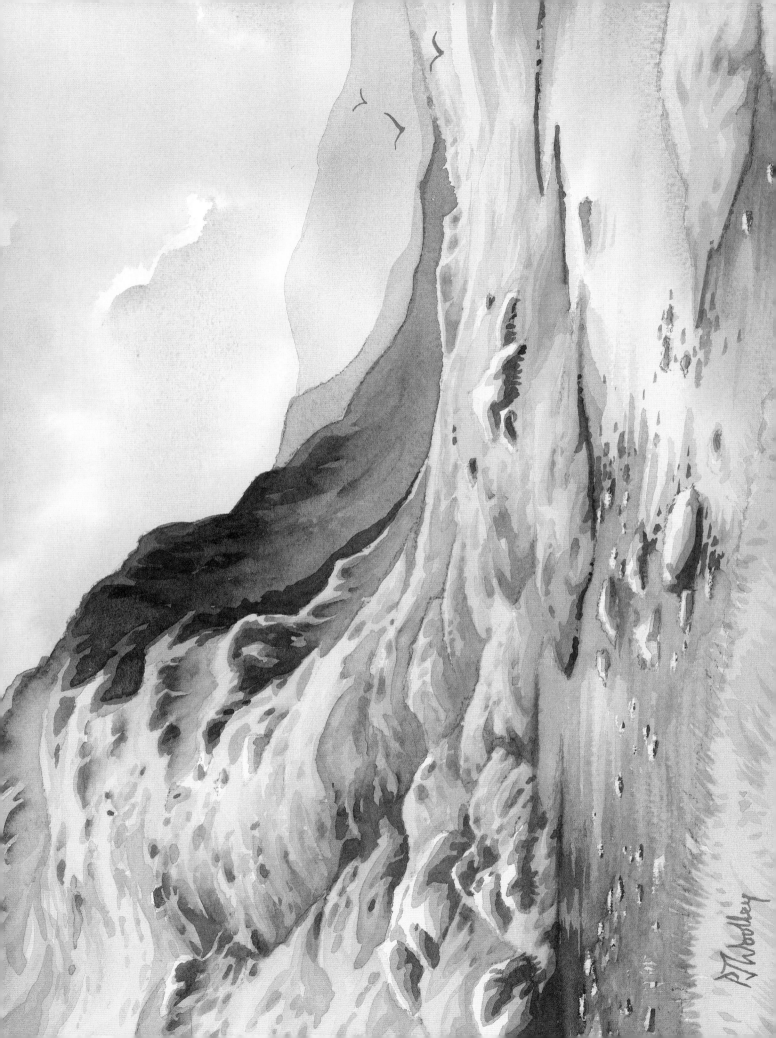

FARM IN THE VALLEY

The appearance of hills can be altered by many factors. Their colours will often differ during the year, for example, when the heather is out or when the bracken is at its height. When the weather is stormy, hills can look bleak and menacing, yet bright sunlight can give them an altogether friendlier mood. One of the less obvious things that can govern how hills look is the combination of clouds in the sky and the prevailing winds. On days when the weather is changeable and the sky is patchy, patterns of light and shade can appear on their surface.

I have chosen this painting of Moor Rigg Farm, below Wild Boar Fell, to illustrate this effect of cloud shadows on the landscape, which is an effect I could happily sit and watch all day.

PALETTE OF COLOURS

- Prussian blue
- French ultramarine
- Burnt umber
- Cadmium yellow
- Cadmium red

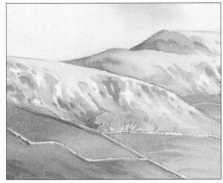

In watercolour, we should always be thinking about tonal contrasts. It is important to distribute alternating values carefully so that objects maintain their visibility in relation to their surroundings.

When clouds pass silently across a landscape, they cast shadows. If you stand and watch their movement, you will see that the light is constantly changing; hills are bright one minute, the next, they are in darkness. This constant changing of light is very useful to the painter of hills and mountains; it means we can pick and choose our moments, engineering the light and shade on a hillside to get the best out of our landscape. Here, darkening the tops of the hills on one side has helped to enhance the layers of land and undulations in the ground.

Darkening selected fields helps to maintain contrasts with the stone walls and the house in the foreground.

It is very important in a scene like this to identify where all the highlights are going to go quite early on. Which fields need to be darkened with shadows will depend entirely upon where the highlights are within the composition. The walls and sheep need to be left untouched. I always prefer to paint carefully around them, but masking fluid is always an option to be sure that you do not lose any significant walls.

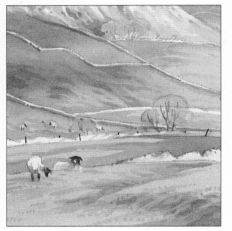

I have applied a similar light-and-shade technique to the foreground field to suggest undulations in its surface. Gentle contours on the ground can provide a feast for the eyes and, if carefully located, can even help to draw the eye in towards the focal point. Of course, overkill in such matters needs to be avoided. At some point, a value judgement needs to be made as to whether a portion of ground is going to look best untouched, with just a single, flat colour, or whether it needs enhancing.

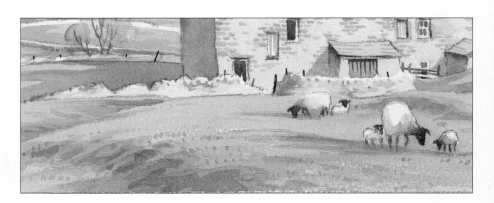

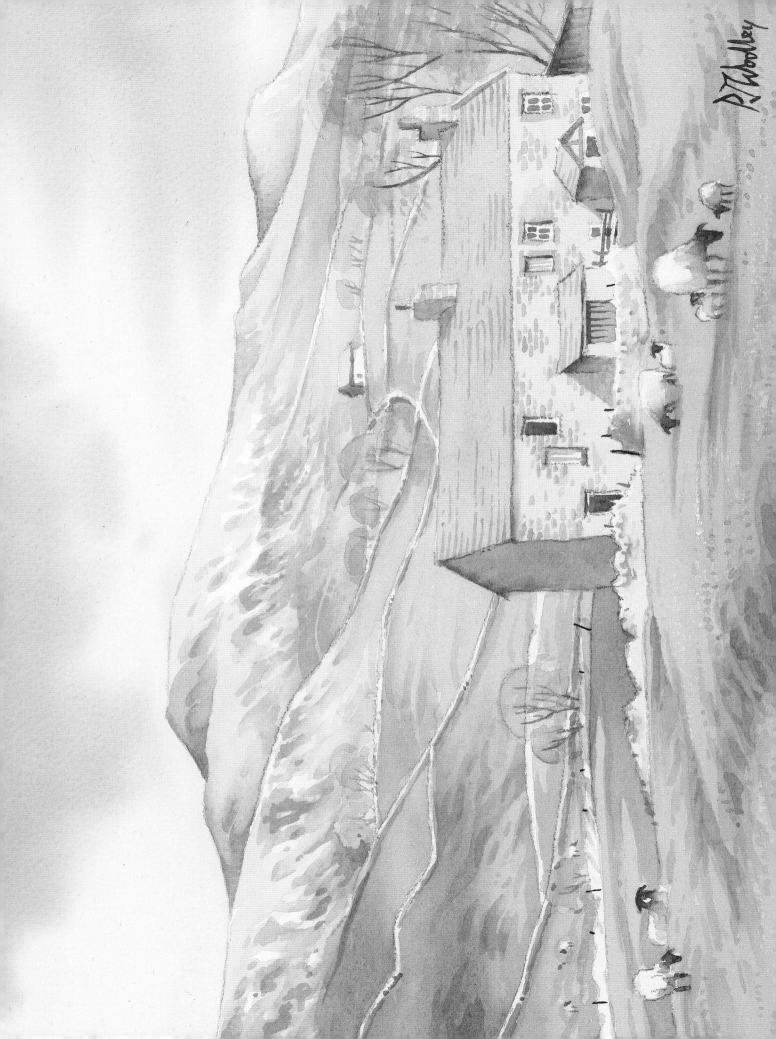

ROCKS AND SCREE

This is the view towards Great Gable, in the Lake District, as seen from Broad Crag, just below England's highest mountain, Scafell Pike. It is a scene typical of an area festooned with rocks of many different shapes and sizes; the result of centuries of erosion and glaciation. As a painter, I am fascinated by landscapes like this, mostly because they are so visually interesting. We should always aim to provide interest for our viewers, offering a view that arouses curiosity and makes them wonder: 'What is just around that corner?' and 'How steep is the drop just beyond that line of rocks?'

PALETTE OF COLOURS

French ultramarine

Burnt umber

Alizarin crimson

Cadmium yellow

Prussian blue

There is a lot happening in the foreground of this scene, so it was important to keep the background relatively simple. I have achieved this in a couple of ways. Firstly, I have created aerial perspective by keeping the tones light and the colours relatively cool. Secondly, I have created some valley mist by softening off the bottom of the hills with a damp brush as I painted them. This has simplified the background and added an air of mystery without creating too much of a distraction. It is very important for a background not to compete with the foreground.

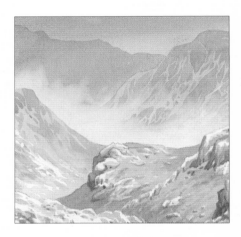

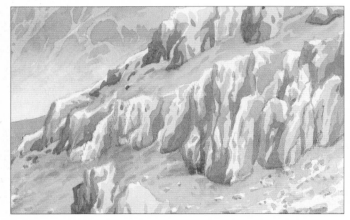

There is always a choice that needs to be made quite early on when approaching a scene like this and that is which to paint first, the rocks or the grass between them? I must confess to using both approaches at different times. In this instance, I opted to establish the lighter grey of the rocks first, then add the green later.

Notice how the smaller rocks, between the crags, help to explain the lie of the land. They must be randomly distributed, of course, to look natural, but you must always maintain consideration for the contours of the ground upon which they lie.

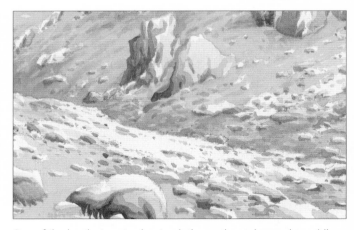

One of the hardest parts about painting rocks and scree is avoiding repetitive patterns. Spacing between all the different elements should be devoid of any sort of regimentation, and they should take on a variety of sizes and shapes. Even the vaguest hint of repetition can start to look unnatural or, worse, man-made. A cast-iron solution to this potential problem is difficult to find; brushstrokes need to be applied haphazardly, but still with a logical structure. I recommend you look out for the unexpected and embrace any 'happy accidents' that may occur.

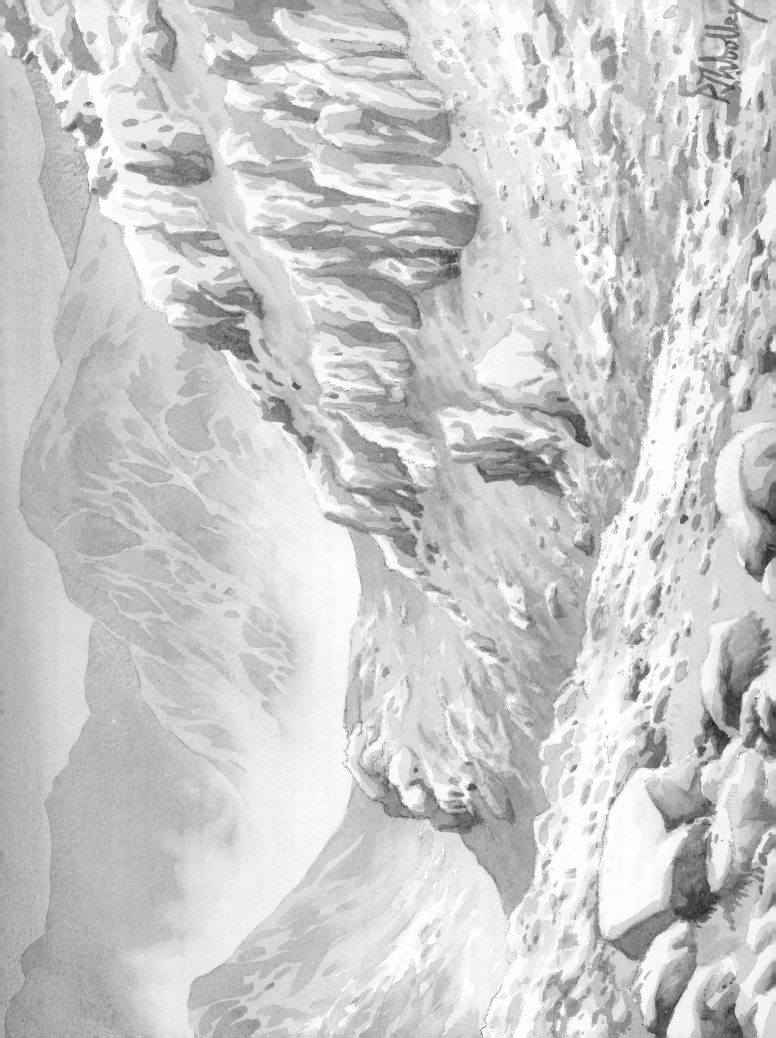

MOUNTAIN STREAM

Water is an integral part of hilly or mountainous regions. It can provide life and movement to what might otherwise appear as a static scene, cutting its way through the landscape, forging gullies and valleys and heading towards larger rivers further downstream. Here, a fresh, young River Etive curls its way through the Highlands of Scotland, overlooked by the peak of Buachaille Etive Mor in the background and bounded by warm autumnal foliage.

PALETTE OF COLOURS

Cadmium yellow

Cadmium red

Prussian blue

French ultramarine

Burnt umber

Alizarin crimson

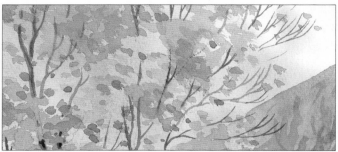

When embarking upon any scene like this featuring foliage, I often like to start with a wet-in-wet wash consisting of the blue of the sky (mixed from Prussian blue) and including a rough impression of where the foliage is going to go (cadmium yellow). Having established such an 'under-wash', I can then build up the foliage in wet-on-dry layers. Because I want to have an autumnal feel in this composition, the colour should be mixed from cadmium yellow and cadmium red.

With foliage, it is important to avoid creating repetitive patterns, and to make the continuity of the branches believable; if a branch disappears into leaves and then reappears further up the tree then we have to believe that they are part of the same structure.

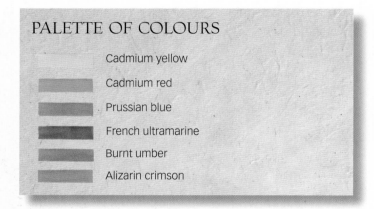

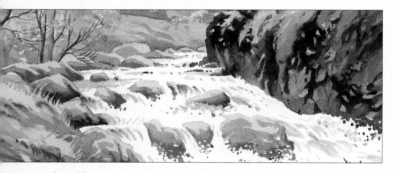

The white water was created through negative painting: I painted in the rocks first and left the water as untouched white paper for as long as possible, adding in the brush-marks last of all to explain the water's shape and movement.

I have created the effect of spray by using the negative painting technique and literally jabbing the brush at the paper in a random fashion. Here, the dark brushstrokes indicate glimpses of rock as seen through many tiny gaps in the white of the water. Another way to achieve this would be to apply small amounts of masking fluid to these areas, which would provide you with the freedom to concentrate on painting only the rocks.

For the water to have maximum impact, keep details to a minimum. Simple, carefully selected marks using a light French ultramarine and burnt umber mix are all that is needed to explain the shape of the water and the direction in which it is flowing. Notice, too, how placing the darkest tones of the rocks alongside the whitest parts of the water also helps to increase its impact.

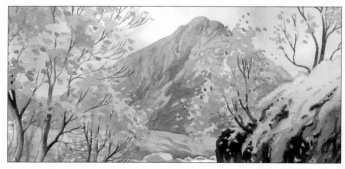

In this scene, 'aerial perspective' allows the mountain to remain firmly in the background: the light tone and cool colour helps to create the illusion of space and depth in the composition.

Another way we can keep distant objects back is by reducing the amount of detail we apply to them. Here, you can see that I have only used two layers, one of French ultramarine and the other, a mix of French ultramarine and alizarin crimson, to suggest surface details. Graduating the hillside to a darker tone near its base has provided much needed contrast with the lighter tones of the trees.

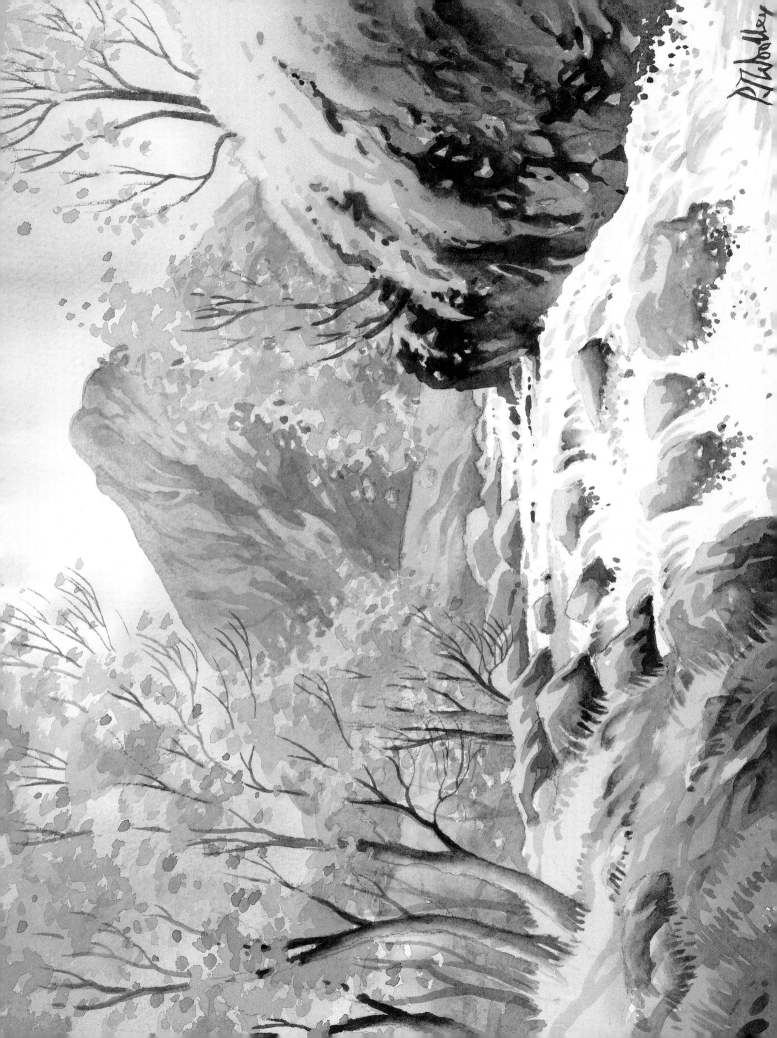

TRAVERSING THE RIDGE

Snowdon in Wales is one of Britain's finest and most exciting mountains and Crib Goch Ridge is one of its more challenging and dramatic approaches; best avoided in bad weather, but highly recommended in clear conditions. As a painting exercise, it poses several interesting challenges. Take care to ensure that the layout of rocks and the contours make sense and reflect the overall three-dimensional shape of the ridge. To reinforce the illusion of space and depth, details must be concentrated in the foreground and thinned-out the further away they are.

PALETTE OF COLOURS

- Prussian blue
- French ultramarine
- Burnt umber
- Alizarin crimson
- Cadmium yellow
- Cadmium red

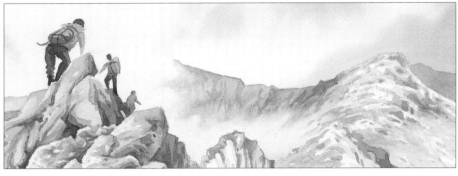

Always start out simple, however complex the scene may be. I began by laying down a wet-in-wet wash for the sky. I used a combination of Prussian blue and French ultramarine and arranged the clouds in such a way as to draw the eye in towards the figures on top of the ridge and the unseen summit immediately behind them.

With a damp brush, I softened off the background hill to give the impression of its summit disappearing into the low clouds and mists clinging to its lower slopes. Hopefully, it has also helped to give the figures more impact so that they do not need to compete with the summit. I do not often include figures in my paintings, but a scene like this benefits greatly from their presence because they provide a scale reference. Without them, we would be left guessing how large the ridge is; with them, there is no such ambiguity.

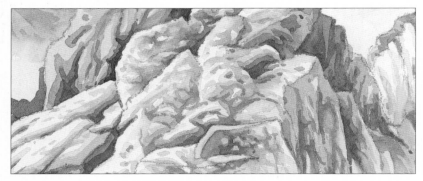

There are no set rules for painting rocks; every rock is different. I always like to start by establishing a general outer shape and then identify where the lightest and darkest parts are. After that, I begin to break the rock down into smaller portions, looking for cracks and undulations in its surface. Tackling every single rock in this way, when the scene involves many rocks, large and small, is not always very practical so a shorthand is needed; an impression of rocks is often sufficient, if not better, than something that might be cluttered up with too much visual information.

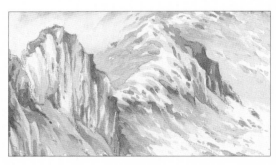

As the ridge recedes away from us, the rocks should appear to get smaller and the details diminish. The light source must remain consistent. This may seem a minor point, but note how important it is for all the darkest tones to be placed on the same side of the ridge. This consistency helps to maintain the general structure of the hill and makes sense for the viewer. The colour of the slope changes from a fresh green mixed from cadmium yellow and Prussian blue to a much wilder, russet colour, mixed from burnt umber and cadmium yellow. This change in colour is also a good visual indication of altitude.

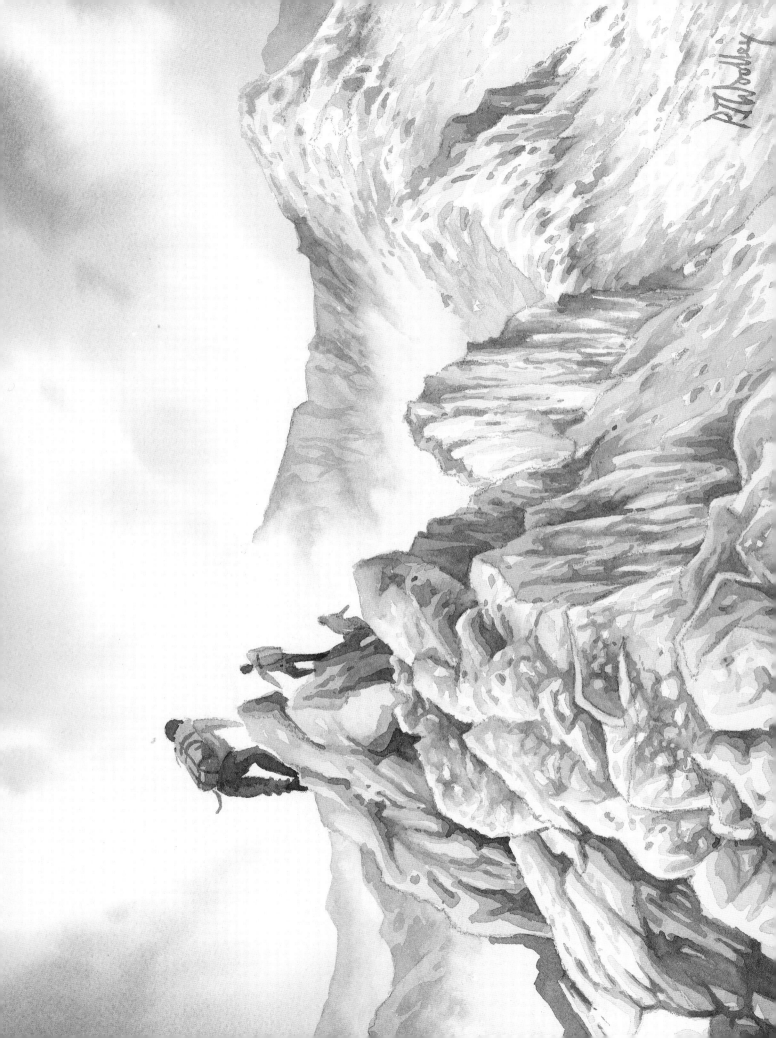

SUNSET: BEST TIME OF DAY

Living on the edge of the Yorkshire Dales as I do, I get to experience many moments like this, when the sun is about to sink below the horizon, and the entire landscape is bathed in a warm evening light. Long shadows abound, and objects are reduced to their simplest forms.

As painters, we are faced with the task of simplifying the landscape by whatever means available. The longer we look at a scene, the more we see, but too much information can clutter up a composition and make it uncomfortable to look at; most of the time, clarity and brevity are preferable. Sunset provides us with this perfect, minimalistic scenario because the scene will not stay the same for long.

PALETTE OF COLOURS

- Prussian blue
- French ultramarine
- Burnt umber
- Alizarin crimson
- Cadmium yellow
- Cadmium red

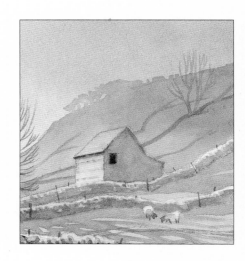

In the last light, hills are reduced to simple blue shapes and the trees that grow along their crown take on more importance. After laying down an initial wet-in-wet wash of cadmium yellow, cadmium red and French ultramarine, I applied the background hills as a graded wash of French ultramarine. Graduating the hill to cadmium yellow as it nears the glow of the sun helps to increase its dramatic impact, and also gives it a three-dimensional shape. Once established, it is very tempting to start adding further contour details to the background hills, but they will always have more impact if they are kept as simple and clutter-free as possible.

The glow from the sun can be enhanced by altering the colour of surrounding branches. I have graduated them from dark silhouettes to a warm orange colour (a mix of cadmium yellow and cadmium red). The sun was lifted out with a scrunched-up piece of tissue while the wet-in-wet wash was still damp. If you want to create a perfect circular orb, one way is to wrap a small coin in the tissue to lift out the colour.

As in real life, the sun affects everything. Its light permeates throughout and changes the appearance of both the hillside and the trees. Even the highlights along the top edges of the stone walls have been given a hint of the colour. Of course, once you place the orb of the sun, you have to think very carefully about the shadows it would create; badly placed shadows can ruin a painting in one fell swoop. We should always seek to exploit shadows to our advantage: at this late hour of the day they get longer and, by following any undulations in the ground, they can help to enhance our understanding of the contours of the ground.

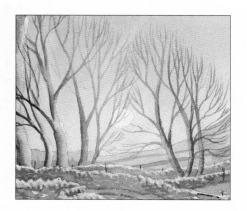

The dictum 'less is more' is never more appropriate than when applied to dry-stone walls. As with most things in watercolour; it is often what you do not see that makes a thing more convincing. Here, I have only painted in a few carefully selected wall details instead of every single one. Remember that with dry-stone walls, the focus should be on painting the spaces between the stones more than the actual stones themselves.

I built up the wall in layers, starting with an all-over light grey colour (mixed from French ultramarine and burnt umber). I then suggested stone shapes with a slightly darker mix before applying the darkest, most intense tones. Constant softening off and blending in always helps to maintain a random looseness to it all.

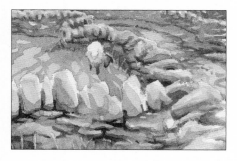

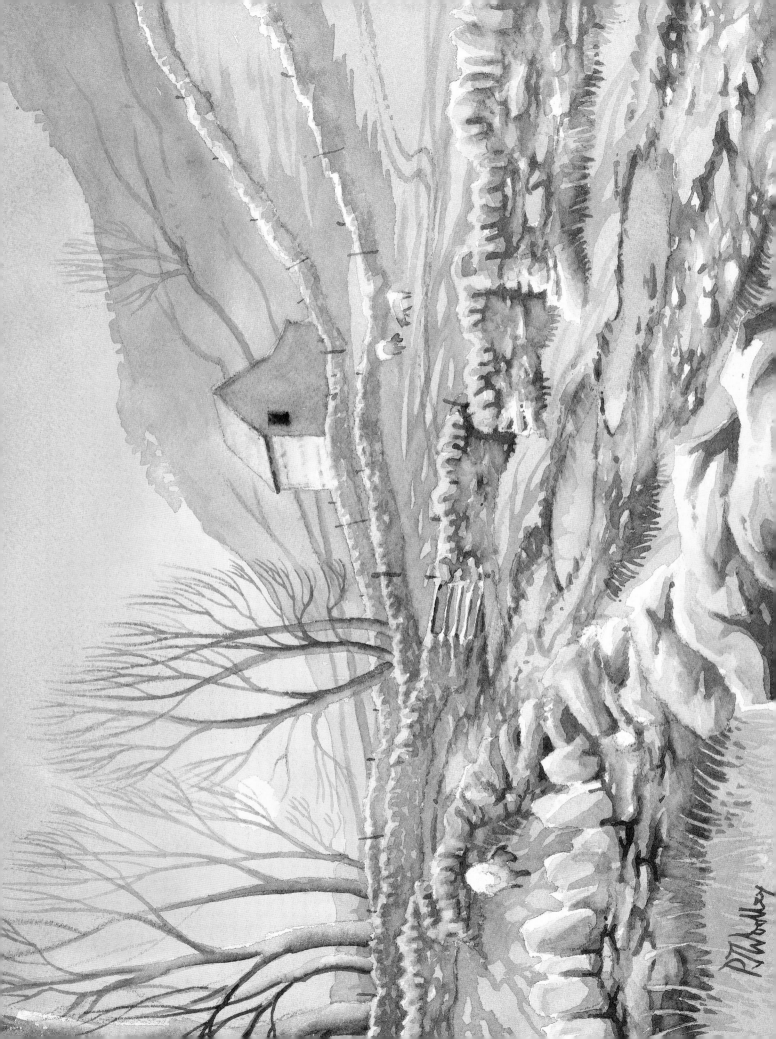

HILL FARM

Despite being a playground for many walkers and visitors, the countryside remains primarily a place where farmers make their living. In the hills above Grassington, in Yorkshire, UK, sheep farming is still the main industry. Stone walls that have been standing for many centuries still divide the land up according to stewardship and one can observe relics from the past that act as reminders of livelihoods gone before, such as the old mines that were once a source of lead and tin. Farm tracks connect the fields and properties and, in this painting, provide an ideal 'path of vision' drawing the eye towards the barn.

PALETTE OF COLOURS

- Cadmium yellow
- Cadmium red
- French ultramarine
- Prussian blue
- Burnt umber

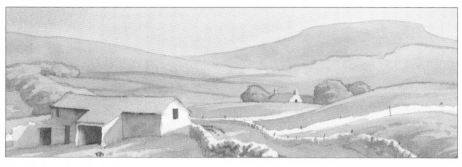

Hills are ever-present in the background of any Dales scene. I prefer variation among them as opposed to simply using a single colour. It reinforces the fact that they are three-dimensional and increases their realism. Here, I have graduated the distant hill from a light cadmium yellow to a light French ultramarine. Note that I have applied the colours light enough to allow the initial wet-in-wet wash to show through. Be sure to remember the value of the white of your paper; it is helpful to think of it as a backlight. If you apply paint too heavily, then you are preventing the backlight from showing through, which may result in a dull, muddy painting.

Notice how important it is to leave a highlight along the top edge of the wall. This creates a contrast against the darker shadow behind it. If the highlight was not there, the overall definition would be severely compromised.

Paintings should have contrasting tones throughout (see Tonal Landscape on page 16, to see this in action). You should be able to get from one side of the paper to the other via alternating tones; hopping from light to dark. If two tones of equal, or similar value are placed alongside each other, the whole composition may be weakened by it.

Although there is a lot happening in the foreground of this composition, we should never overlook the background. There is a hierarchy to how people view paintings: the eye will be drawn into the scene and toward a focal point (in this case, the barn). This is the primary path of vision. What happens in the background will be a secondary experience. Having enjoyed the main focal point, our viewer will say 'Look at those trees on the background hill... I never noticed those before...' Make sure that secondary details are available to our viewer should they go looking for them, but it is equally important to make sure that those details do not compete with the more significant aspects of the composition and upset its overall balance. Every painting should have a focal point – a single point of interest where the eye is drawn – and the rest of the composition should support this. The stone walls are a good example as they help to draw the eye in towards the barn.

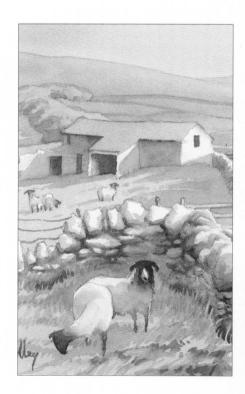

STONE WALLS IN THE HILLS

One cannot help but be impressed by the sight of stone walls as they stretch out across the hilly slopes. Who were the people who built them? What were their lives like? One imagines it must have been a tough existence. Today, we mostly take the walls for granted, but the legacy of the builders remains. Here, in Cotterdale, the curve of the valley is graced by, and accentuated by, many miles of stone walls that follow the undulating contours of the ground.

OUTLINE 16

PALETTE OF COLOURS

French ultramarine

Cadmium yellow

Prussian blue

Burnt umber

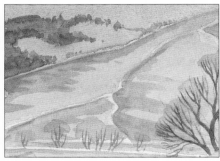

I began painting this scene by applying a graded wash of French ultramarine to the background, bringing it as far down as the curve of the hill in the middle-distance.

With a light green mixed from cadmium yellow and Prussian blue I applied tentative brush-marks to the far hillside, explaining its contours with broad, curved strokes and leaving the walls and the buildings in the base of the valley as untouched highlights.

To suggest spring foliage, I have painted the trees as if they were winter bare, and applied a light wash to their upper branches. Another method of creating light foliage is to apply it using a dry-brush technique, where the paint just catches the top of the paper texture creating a broken, scattered brush-mark.

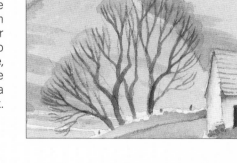

Sheep are relatively easy to paint; once their outer shape has been established as a highlight in the green grass, a dark tone should be added to their heads. While it is still damp, soften the dark tone off and blend it back into the body using a light, mucky sheep colour mixed from burnt umber and cadmium yellow. Take care to leave a highlight along their backs to maintain maximum definition.

I mixed my shadows from French ultramarine and burnt umber and laid them over the top of my previously painted greens. This is more efficient than mixing colours for, and painting, each section separately. Overlaying washes like this allows the green to show through, exploiting the transparent properties of the medium and becoming an integral ingredient of the shadow.

The light tone of the stone wall has been exaggerated by the contrast in tones; the lighter we want something to appear, the darker the adjacent tone needs to be.

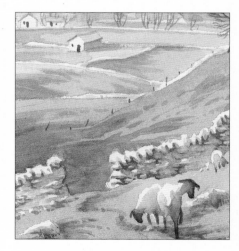

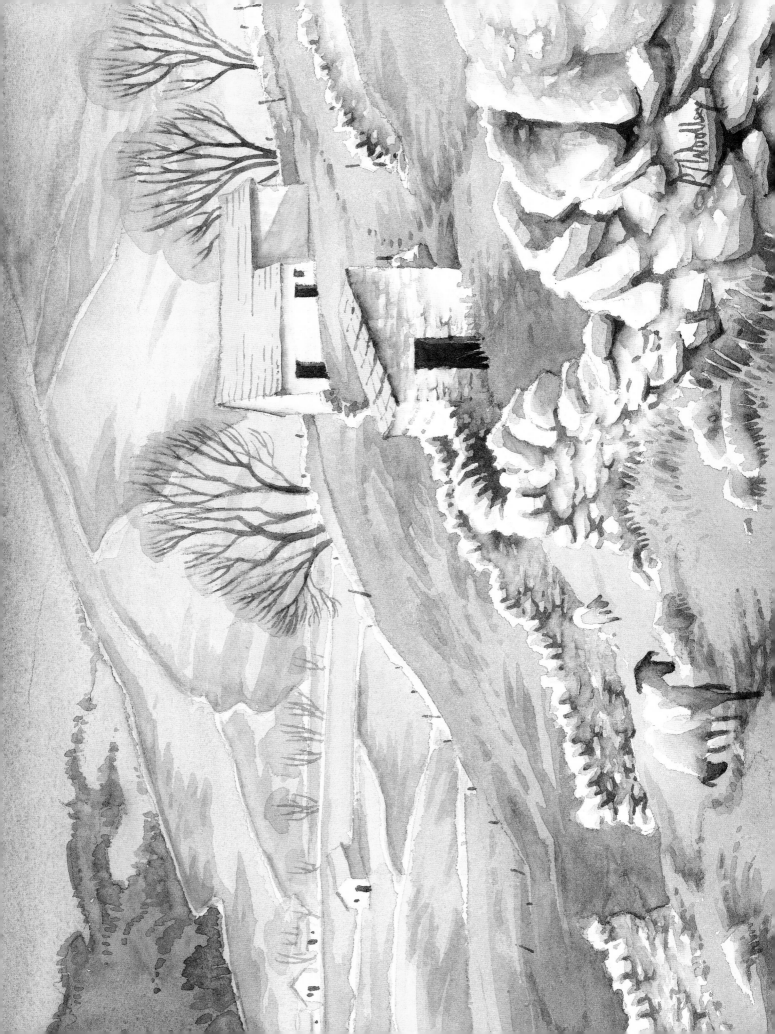

FIELDS AND TERRACES

When in the countryside, you will often find hillsides are marked by the division of farmland. The hills and slopes of the landscape are often segregated by either walls or, throughout the UK, hedges. In some cases, copses and lines of trees are also used to separate one farmer's land from another.

These divisions are a gift, providing us with a visual key to explaining the rolling landscape. One of the biggest challenges we face with a scene like this is how to avoid creating patterns in the field boundaries that are too repetitive or too geometric. While the walls themselves may be clearly delinteated, the land beneath them undulates in a random fashion; it is these natural contours that help to dictate where the boundaries should lie.

PALETTE OF COLOURS

French ultramarine

Cadmium yellow

Prussian blue

Burnt umber

Cadmium red

Alizarin crimson

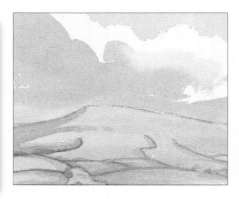

As always, the key to dealing with a relatively complex scene like this is to start as simply as possible. On this occasion I have kept the sky wash above, and separated it from, the line of the background hills, aiming for a clean differentiation between the two. I have deliberately kept the sky simple so as not to detract too much from what is happening in the rest of the painting; we would not want the two to compete with each other.

To ensure that the trees do not clash with the fields, I decided to paint them in with a light autumnal colour mixed from cadmium yellow, cadmium red and burnt umber. For the darker tone, I added French ultramarine and a hint of alizarin crimson to the mix.

Nothing punctuates a landscape more effectively than a copse of trees; it is easy to imagine that somewhere beneath them there may be a stream or two. Hills may be shaped by nature, but they are largely clothed by the hand of man.

Trees fall into two categories; those that have stood for hundreds of years and are indigenous, and those that have been planted more recently, often as windbreaks for farmland. It is quite easy to distinguish between the two, since those planted by farmers are usually regimentally spaced and in straight rows, while the more natural woodlands are totally random and unpredictable. I know which I prefer.

Do not overlook your foregrounds. Furrows left over from farmers harvesting the land provide a useful device for making a foreground interesting without being too overbearing. Whilst these are evenly spaced (unless the farmer was not really paying attention to his task), they must obey the laws of perspective and appear to get narrower and closer together as they recede away from us. In this scene, the slight curve to the furrows helps to explain the three-dimensional shape of the land that falls away from us. However, there is a balance to be struck: foregrounds should not be so busy and cluttered as to stop the eye from getting beyond them like a visual barrier, rather they should be more of a stepping stone; a welcome introduction to a scene, if you will, like a starter before the main meal.

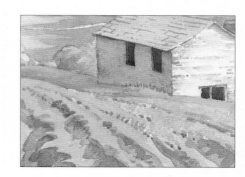

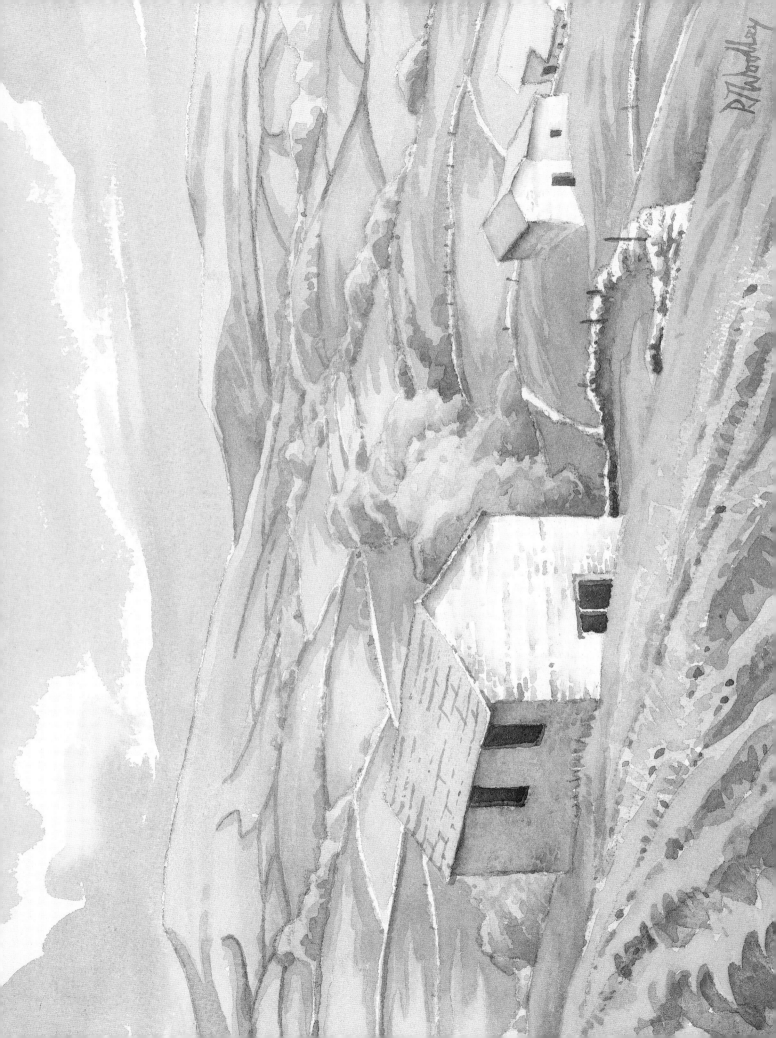

SNOW AND SHADOWS

I love snow-scenes. The landscape is reduced to its simplest form, and in a scene such as this (Striding Edge, below Helvellyn, in the Lake District), the three-dimensional shape of the hillside is explained entirely through shadows across the surface of the snow, and rocks.

This painting has also been produced with only three colours. As a general rule, we should aim to use as few colours as we can, recycling and reusing colours wherever possible. This helps to prevent a composition from becoming too much of a garish kaleidoscope of colours, and produces something more in harmony with itself. If in doubt, keep it simple!

PALETTE OF COLOURS

- French ultramarine
- Burnt umber
- Prussian blue

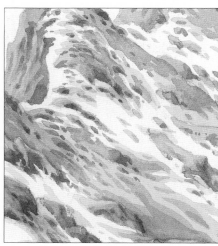

Shadows tell us just as much about the surface they are falling on as the object that has cast them. In a scene like this, it is vitally important to make sure the shadows curve appropriately so that they appear to follow the undulations in the ground.

If we make the shadows straight, then the message we are sending out is that the surface upon which they are falling is flat, which would be a hugely conflicting message for a mountain scene such as this.

Notice how the shadows themselves are also broken down into two or three tones, making them a little more visually interesting than if they only consisted of a single tone; the technical terms for this are 'umbra' (the darkest part) and 'penumbra' (the lighter part).

This painting has been built up using, almost exclusively wet-on-dry layers, meaning that all the brushmarks have been applied to dry paper, creating hard edges throughout. The technique rather suits this particular scene because part of its impact comes from the implied belief that the rocks are hard and that you could easily cut your knees while climbing on them.

No two paintings are the same, so you should always take the time to study your subject first to decide where the hard lines and soft edges fall and whether or not you need to apply a wet-in-wet under-wash first.

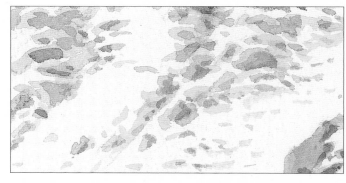

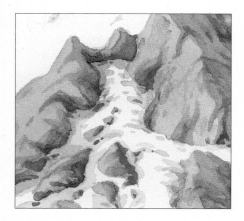

Building up rocks should be done with care to ensure that the shapes you are ending up with are truly the shapes you wish to convey. Having said that, approaching them with a certain amount of flair or ebullient 'joie de vivre' might encourage a more random and natural-looking result. You need to take lots of breaks when painting rocks in order to stand back and monitor their progress. This gives you the opportunity to see them with a fresh eye and, hopefully, make adjustments as you go along before it is too late.

Also, watch out for faces! If you stare at any rock formation long enough, your brain will start to imagine it can see all sorts of things in it – facial features being one of the most common. It is surprisingly easy, when you are not paying attention, to end up with an unplanned face staring out at you. The main problem with that is that once it is there, it can be remarkably difficult to remove. If that happens to you, my best advice is not to mention it to anyone.

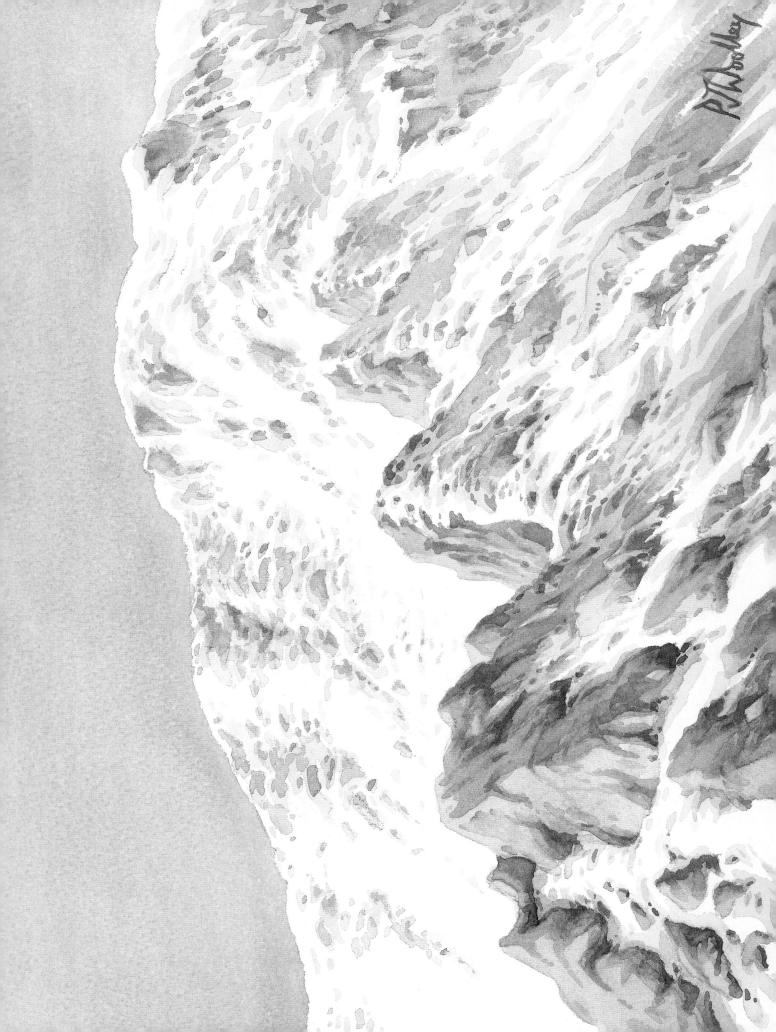

THE ILLUSION OF SPACE

This is the view looking down upon Black Lough in The Gap of Dunloe, Killarney National Park, Ireland. On either side of the lake the mountains rise high and in between them is space. One of the greatest challenges the landscape painter faces is how to create the illusion of this three-dimensional space on a two-dimensional piece of paper.

PALETTE OF COLOURS

French ultramarine

Cadmium yellow

Prussian blue

Burnt umber

Alizarin crimson

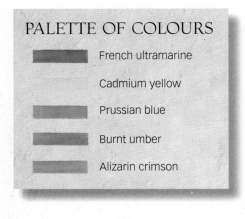

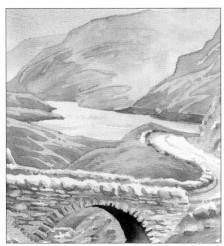

There are two parts to the solution: firstly, mountains should appear to get smaller the further away from us they are; this is what we call 'linear perspective'; secondly, we can make distant objects lighter in tone and cooler in colour; what we call 'aerial perspective'.

There are some other tricks we can employ to create space. Here, I have not limited my initial wet-in-wet wash to the sky, instead I have extended it right down to just beyond the bridge in the foreground. By doing so, the colours from the initial wash (French ultramarine and cadmium yellow) are also visible within the slope of the hills, enhancing the illusion of atmospheric diffusion.

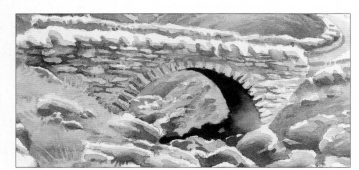

Note how the dark tone under the archway of the bridge graduates slightly; at the top it is about as intense as I could possibly make it, while near its base it graduates to a lighter tone. This has been achieved simply by adding water to the wash as I work my way down the paper, creating the grading effect. The reason I have done this is because, although it is dark beneath the bridge, there would be a small amount of light reflecting upwards onto the arch from the water and the rocks beneath it.

Notice, too, how I have alternated the tones in this area; the light facing wall of the bridge and the foreground rocks contrast sharply with the darkness beneath the arch, only to be contrasted yet again with the light tone of the slope beyond it. This alternation of tones helps to keep the composition visually interesting and is something to aim for in all paintings.

Track marks on the road help to reinforce the perspective and the illusion of space within the scene. The small rocks and stones in the foreground have been created by leaving small, random highlights in several increasingly darker-toned overlays. These highlights can then be further exaggerated by placing a few extremely dark tones against a selected number of stones.

Roads, tracks and footpaths are useful compositional devices because they provide a way into the scene; a clear, visual route for our eyes to follow. In this scene, not only does it draw us in, but it also continues on, crossing the bridge and going beyond. Such a blatant path of vision makes the composition accessible and easy to interpret by even the most distracted observer and is a device that should not be underestimated. It can be the visual glue that holds all the elements together.

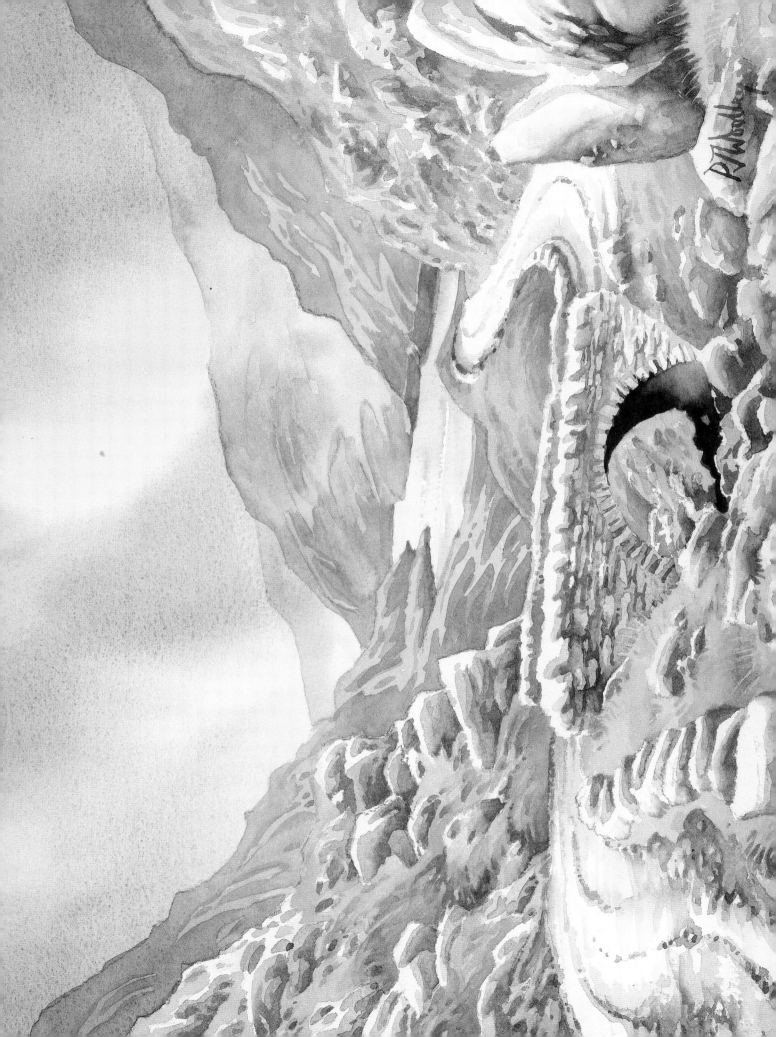

WOODED HILLS

Woodland plantations are a common sight among mountains and hills. This is the view looking down upon Ullswater from Little Mell Fell in the Lake District. At this high viewpoint, we are just above the timber line and most of what we see below us is shaped and visually defined by the trees clinging to the slopes. The gap between the trees and the slope to the left provides a natural line-of-sight towards the lake, while the slope in the immediate foreground provides us with an explanation of the viewpoint and helps to root the viewer in the scene.

PALETTE OF COLOURS

- Prussian blue
- Cadmium yellow
- French ultramarine
- Burnt umber
- Alizarin crimson

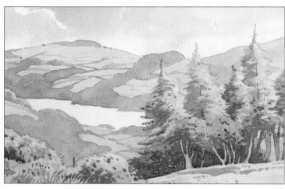

Individually, trees are beautiful objects; collectively, they can create interesting shapes when viewed from a distance and help to explain the contours of the hills they cling to. To add further interest, and to prevent them from looking too flat and two-dimensional, I have varied the colour slightly, making sure that they are at their darkest where they meet the lake.

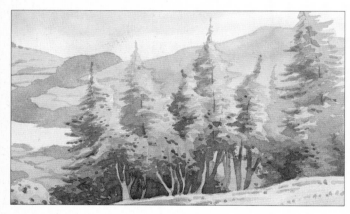

I have rendered the foreground trees using a couple of techniques. Mostly, I have built up the foliage using a light green for the overall shape, mixed from cadmium yellow and Prussian blue, a mid-toned blueish green (the same green, but with extra Prussian blue and burnt umber added) to establish the main areas of light and dark and a darker green to pick out a selected few details within the foliage. Along the lower portion of the trees, I have varied the tree trunks by alternating between colouring them dark against light and creating light tones against dark through negative painting.

One of the most important things to aim for in a group of trees like this is variation. Avoid making them look identical in shape or spacing them too evenly apart.

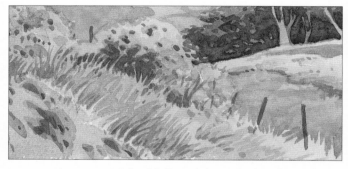

In watercolour, we work from light to dark. This is fine providing we know where all our light tones are going to go and have planned far enough ahead to allow for it. Painting around light objects is not a problem until those objects are as fine and awkward as these blades of grass. There are several solutions to the problem available to us, for example, light-toned grass blades can always be scratched-out or painted in using gouache. Personally, I always prefer the negative painting method, by which I mean I do not paint the grass directly, but create the grass blades by applying a dark tone around them.

Here, the darker tone has been worked into the lighter tone, leaving grass-shaped highlights that can then have light yellow or green applied to them to complete the effect. The most important thing is to try to avoid making the grass too repetitive or too straight. Grass should be curved slightly to suggest light movement.

HILLS AND LAKES

Where there are hills, you will find water and many of the mountainous regions of the world also feature beautiful lakes. This is a view looking down the length of Ullswater from Watermillock near its northern end. It is the second largest lake in the Lake District, being almost 14.5 kilometres (9 miles) in length, and having a maximum depth of 60 metres (197 feet). No Loch Ness Monster here, just lots of steamers, yachts and fishermen.

OUTLINE
21

PALETTE OF COLOURS

Cadmium yellow

Cadmium red

French ultramarine

Burnt umber

Alizarin crimson

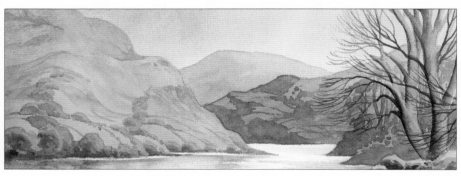

I chose the early evening for the setting of this piece when the last rays of the sun are just catching the tops of the surrounding fells and the shadows are at their most dramatic.

An initial wet-in-wet wash of cadmium yellow, cadmium red and French ultramarine helped to set the mood of the piece and provided a warm base upon which to apply my hill washes. For these, I repeated the same three colours, but graduated the yellow down to the French ultramarine vertically in order to explain the light of the sinking sun.

Fell-sides are rarely straightforward, but this is what makes them so interesting. Undulations on the surface of the hills have to be dealt with in a subtle way so as not to make them look too busy. Primarly, the viewer should notice the overall shape of the hill while the changes in the ground should be secondary. Only a slightly darker tone is needed to explain these variations.

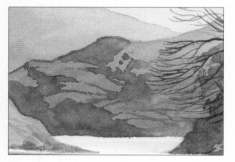

In a scene like this, it is very important to constantly monitor your tones. Contrasting values should be the rule; two tones of equal or very similar value placed alongside each other can substantially weaken the composition. You should always be prepared to exaggerate your tonal contrasts to maximize the definition of individual objects.

This hillside has many field boundaries and trees. In order to show those details without making them too prominent I have painted them all with the same colour and tone, effectively blending them together into a single overlay. The colour is a warm, blue-grey mixed from French ultramarine, burnt umber and alizarin crimson.

It is worth noting how the extreme dark tones of the branches of the foreground tree on the right, reaching in front of the hillside, help to reinforce the illusion of space and depth within the scene.

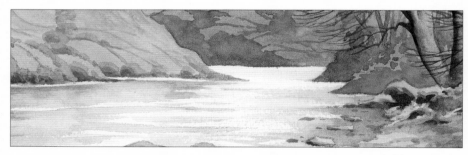

The differences between the rocks along the edge of the water and those visible beneath the surface of the water are two-fold. Firstly, the submerged stones (or more specifically, the dark spaces between the stones) have been painted after a light wash has been applied to the water so that they appear to take on that colour, as opposed to those along the edge of the lake, which are much lighter and brighter in appearance. Secondly, I have applied a much darker brushstroke to the stones that are out of the water than those which are submerged to help differentiate between the two. This gives them greater, clearer definition and more impact.

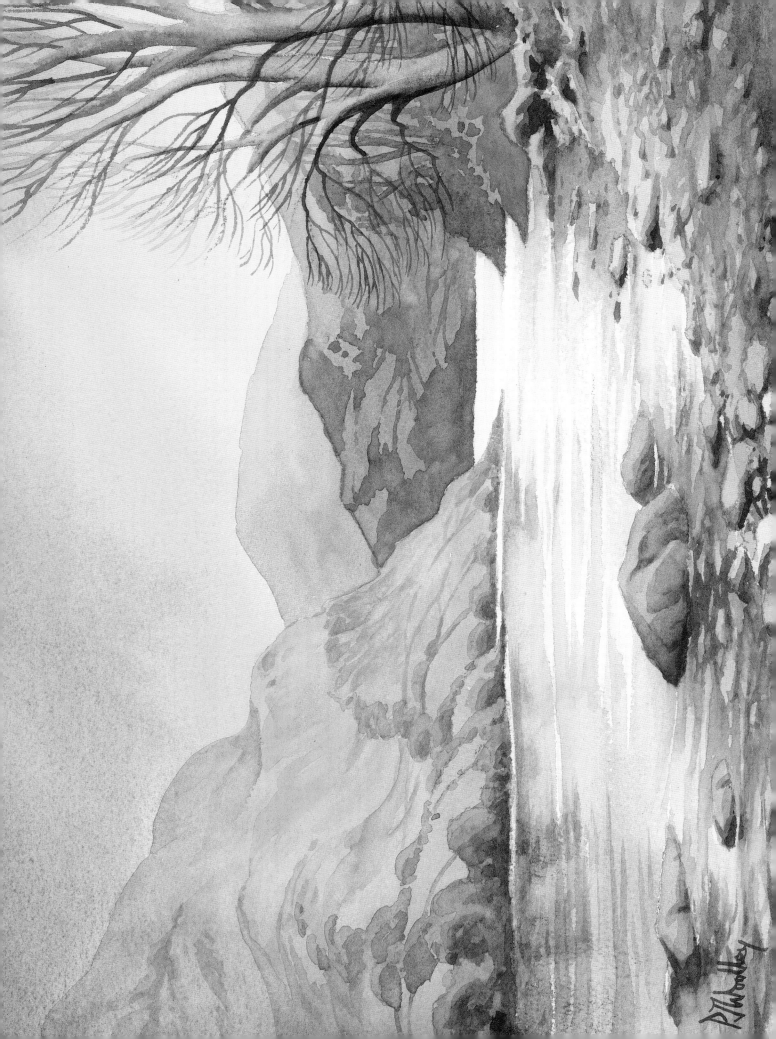

THE WEATHER IN THE HILLS

It goes without saying that mountains and hills can be dangerous places. The weather can turn very suddenly from being fine and clear one minute to wet, cold or snowy the next. If you are going to take your paints into the hills, you should always take precautions against every possibility. Carry weatherproof clothes, even on the finest of days; a map; a compass (and know how to use them) and leave notification of your route with someone at home, should the worst happen.

Painting out of doors can be a challenge at the best of times. I tend to take with me a sketchbook, pencil and a camera and then endeavour to recapture the conditions later in a warm, dry studio where a kettle is near to hand (but then, I am not as young as I used to be).

PALETTE OF COLOURS

- Raw sienna
- French ultramarine
- Burnt umber
- Alizarin crimson

To create this blizzard effect, I used a technique known as 'salt glazing'. I find that sea-salt flakes are best for the job: they are easy to break up between the fingers and the flakes are pleasingly random in their size and shape, resulting in a more interesting and natural-looking effect.

After applying a loose wet-in-wet wash of raw sienna, French ultramarine and alizarin crimson, I sprinkled the sea salt onto the mix while it was still damp and left it to dry. The flakes soaked up moisture and paint from the surrounding wash, leaving behind the pattern that you see here. As with everything else in watercolour, timing is everything: if you drop the salt onto the wash too early, it will soak up more moisture and the pattern it creates will be much larger; If you leave it too late, then there simply will not be enough moisture for the effect to happen at all. Make sure the wash is bone dry before trying to remove the salt, otherwise you will end up with unsightly smears across the paper!

Once the wash had dried, and the salt had been removed, I began to add the rock details. These were simply applied in a series of layers, varying in tone and colour from a light grey (mixed from French ultramarine and burnt umber) to the darkest areas, mixed from French ultramarine, burnt umber and alizarin crimson.

It is worth noting that, if you wanted the salt glazing effect to appear on the rocks, then you should reapply the salt and repeat the technique to maintain the effect.

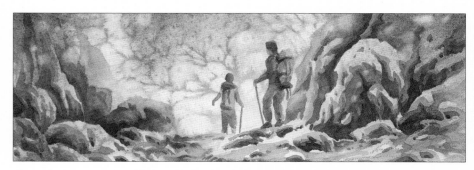

The walkers were painted in last of all using the same light-grey mix to maintain harmony. The effect I was aiming for was of hostile conditions, where humans are pitted against the elements in a thoroughly turbulent environment. This is in contrast to the majority of paintings featured throughout the rest of the book, where even the wildest of landscapes still have a certain beauty about them.

I should just mention that, as well as the salt-glazing blizzard effect, if you look closely, you will see that I have also lifted out a few individual snowflakes with the end of a damp brush.

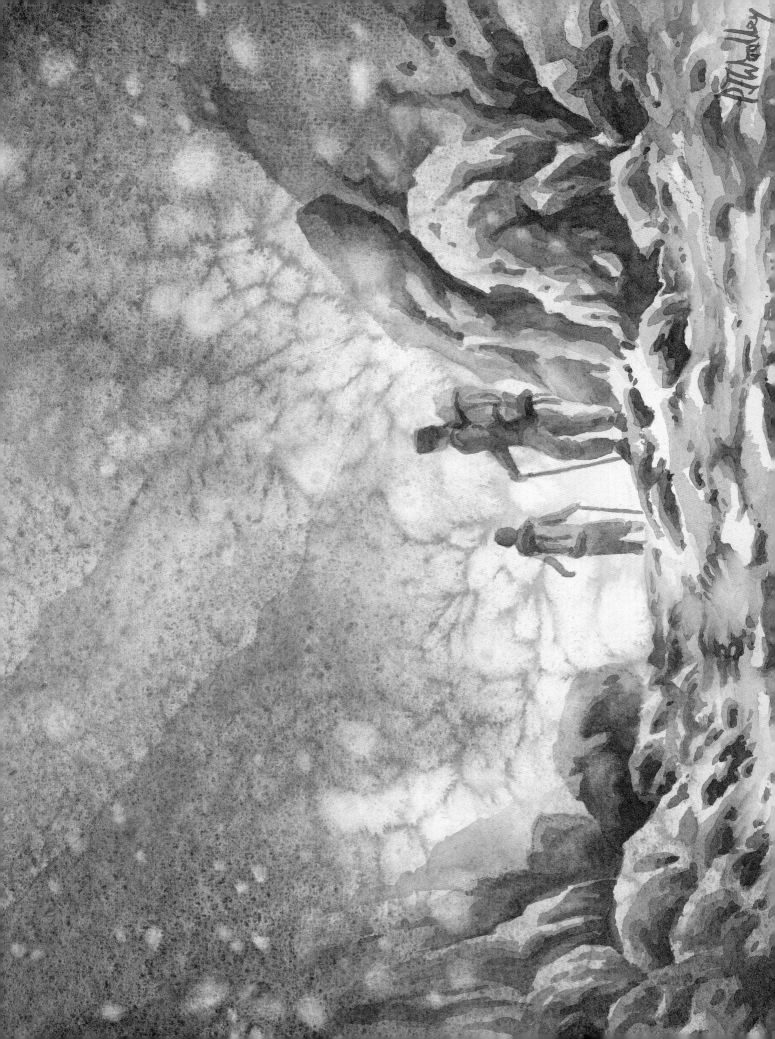

SUNSHINE AND RAIN

The Hole of Horcum, Saltergate in the North York Moors is a place where the weather seems to congregate. The Cleveland Hills draw the clouds and the moisture up from the Vale of Pickering in the west and off from the North Sea to the east, resulting in some spectacular moments such as this, viewed from high up on the road that crosses the moor. Breaks in the clouds produce light and shade in a scene like this, but the presence of rain also adds drama.

OUTLINE
23

PALETTE OF COLOURS

Cadmium yellow

French ultramarine

Burnt umber

Alizarin crimson

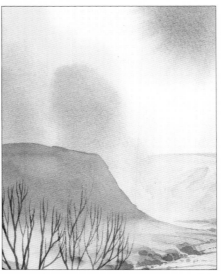

Since clouds and rain are the products of moisture in the air, it seems rather fitting that one of the best ways to depict them is through the medium of watercolour.

I began this painting as a large, loose wet-in-wet wash consisting of cadmium yellow and French ultramarine. To create that glow in the sky, it is important to remember to leave a well-placed highlight somewhere in the central region, extending it down into the valley to prevent sky and valley from being too isolated from each other.

When painting in the hillside mixed from cadmium yellow and burnt umber, notice how I softened it off to create the impression of it disappearing into the rolling clouds. The darker details were mixed from French ultramarine, burnt umber and alizarin crimson.

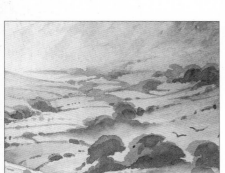

The details in the valley floor were applied using a mix of French ultramarine, burnt umber and alizarin crimson. If you look carefully, you can see how they were built up in a series of about three to four layers, each layer slightly darker than the previous one. It is important to allow the trees and field boundaries to be a little offset from each other, creating a slight ambiguity in the shapes and leaving selected areas entirely open to interpretation.

Hills and mountains are dramatic things in isolation. However, without any point of reference, their sheer scale and potential impact might be lost. The strength of this composition is in the juxtaposition of hills and fields. The farmland details in the base of the valley, diminutive in size relative to the slopes of the surrounding hills, give a much-needed sense of scale to the hills.

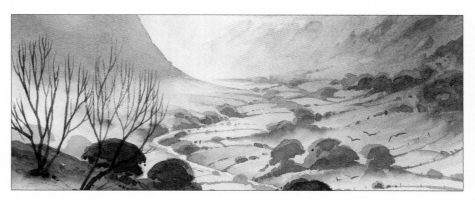

Notice, also, how varying the tone of the trees (ie. making nearer trees slightly darker than those further away) has helped to create a sense of depth within the scene.

Careful distribution of contrasting tonal values is important for every painting. Tone is relative, so the lighter we want something to appear, the darker the adjacent tone needs to be. Never be afraid to exaggerate things if it is going to improve your painting. We should always seek to create the strongest composition we can, and if that means tweaking things and engineering it to make that happen, then so be it.

ICONIC PEAK

Every mountainous or hilly region has a landmark that, for whatever reason, takes on an iconic status. This is Pen-y-Ghent, which along with Ingleborough and Whernside are commonly referred to as 'The Three Peaks of Yorkshire'. Mountainous areas around the world have their own iconic landmarks, from Everest downwards. Such subjects could also be seen as 'pot-boilers' to the artist: an easy choice that one knows is likely to sell. If you paint a well-known hill or mountain then there is a good chance someone will recognise it and if they have a strong enough connection to it then they may even want to buy it. Generally speaking, I try to avoid 'pot-boilers', but even familiar (or done-to-death) subjects are sometimes worth looking at again, perhaps from a less familiar viewpoint.

PALETTE OF COLOURS

French ultramarine

Burnt umber

Alizarin crimson

Prussian blue

Cadmium yellow

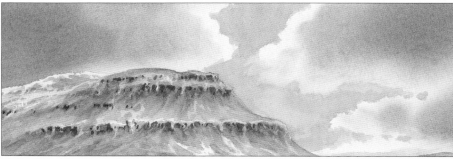

I painted the sky in two stages. I created a wet-in-wet wash, laying down the grey of the clouds mixed from French ultramarine, burnt umber and alizarin crimson. Because it was painted wet-in-wet, the edges of the clouds are soft. In the second stage, after the wet-in-wet wash had dried, I painted in the blue patches. These were applied to dry paper in order to create hard edges, although I have softened off the blue in a few places just for variation. It is very important when painting a sky like this to make sure that the blue is not darker in tone than the darkest part of the rest of the sky.

I chose this viewpoint, because of the rocks in the foreground – collectively known as Brackenbottom Scar. My positioning of the shadows on the rocks helps to establish the direction of light falling upon the scene with well-defined areas of light and dark on their surface.

I created the grasses through negative painting by applying the darkest tones of the rocks down into the grass, leaving the blades as untouched highlights. A light green was added to this later (mixed from cadmium yellow and Prussian blue).

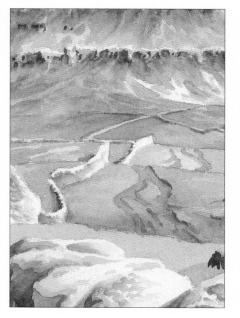

It is important to be aware of the 'interconnectedness' of things. All elements within any composition should be visually linked. Here, you can see that the track leading across the moor, disappearing then reappearing, links the background to the foreground. The brown of the moorland at the base of the hill is the same burnt umber used in the track and the broken earth around the base of the rocks in the foreground.

When painting hills and mountains, we should be on the lookout for ways to draw the eye into the scene and hold it there. Beware of strong lines that lead the eye out of the picture, or scenes that seem to split too equally into two halves. Where this happens, steps need to be taken to link those two halves together; for example, a tree in the foreground that spans both areas might do the trick, or some carefully placed hill fog.

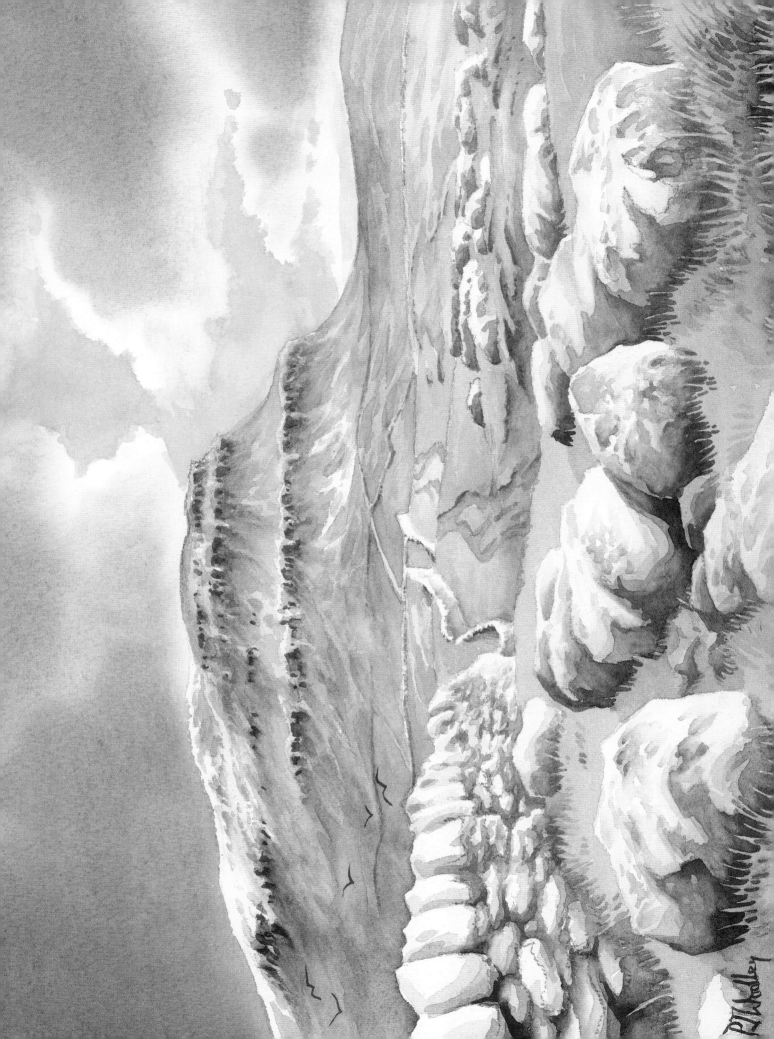

INDEX

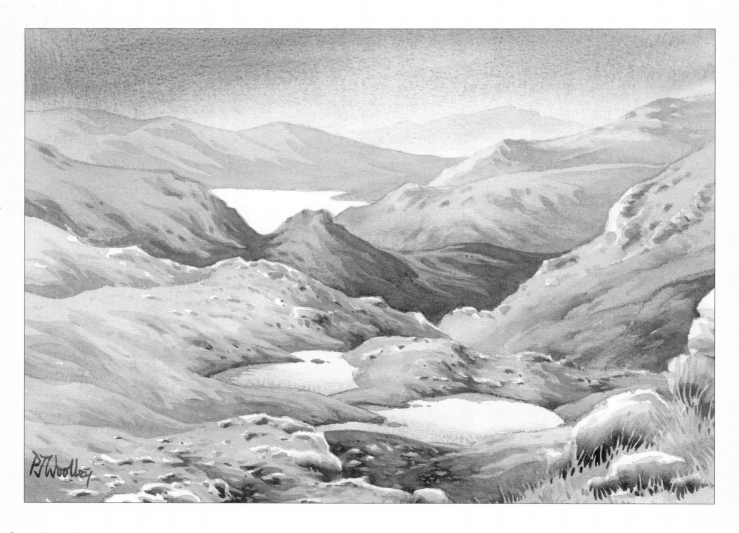

1

2

4

6

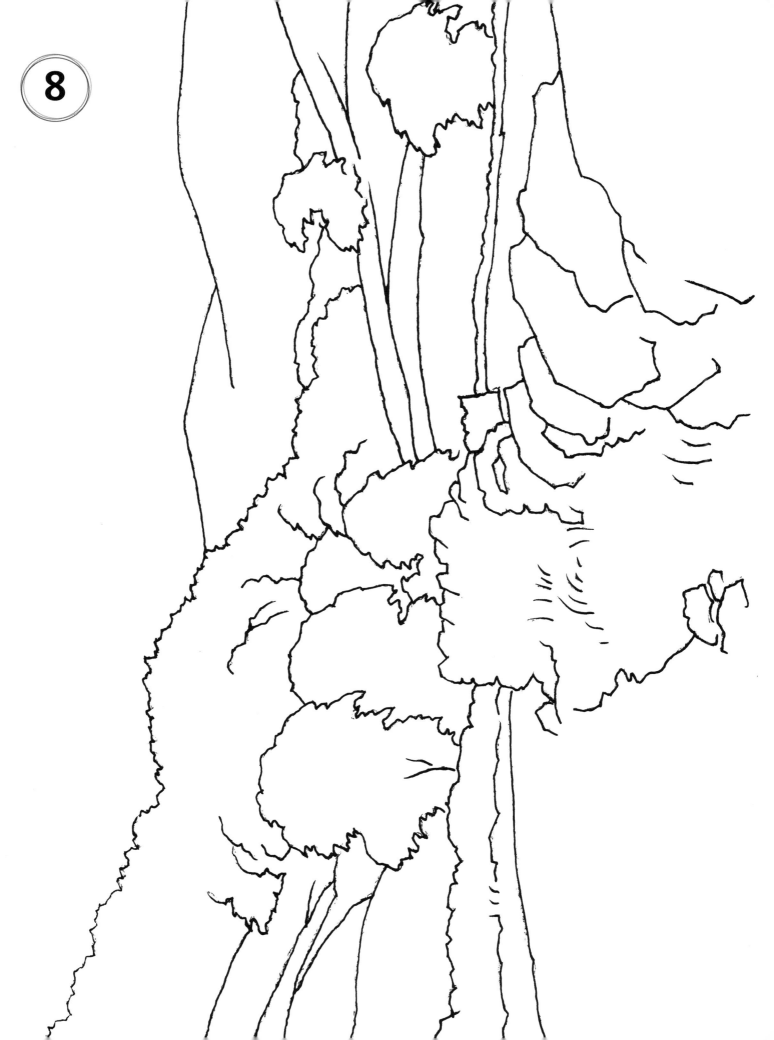

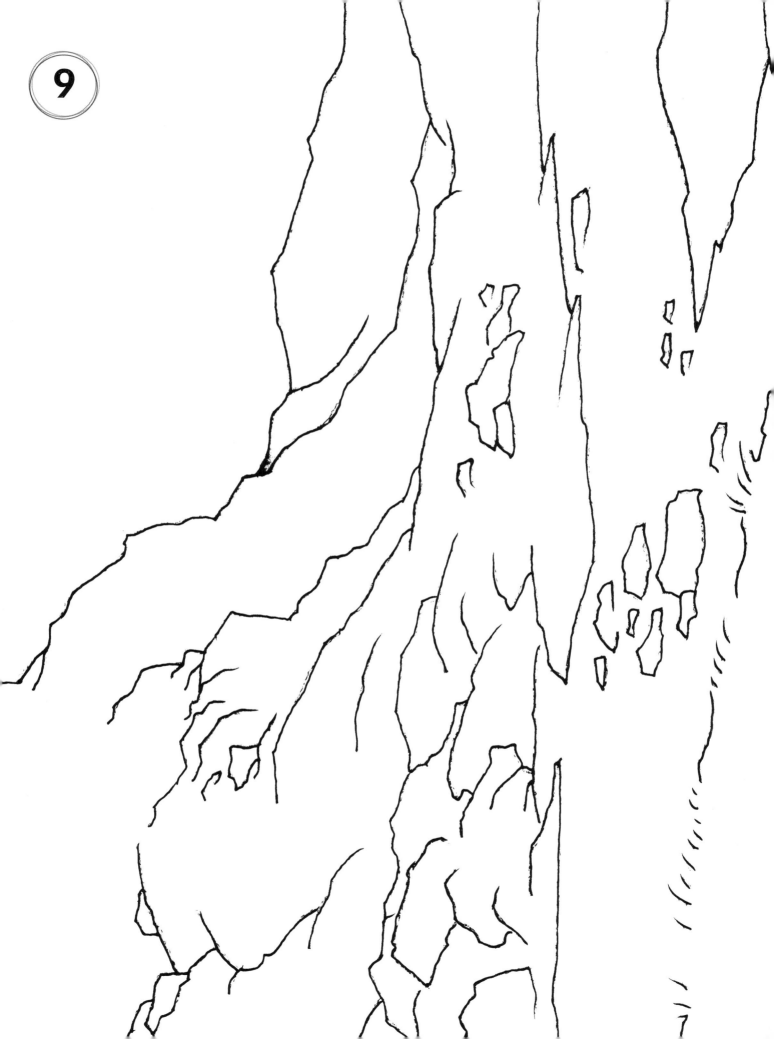

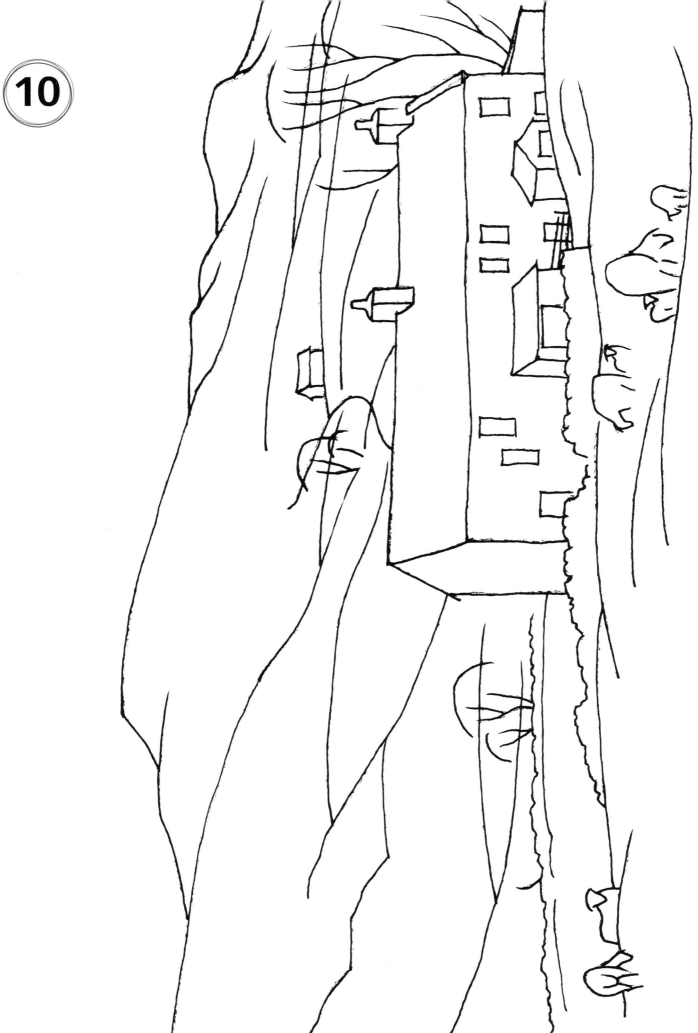

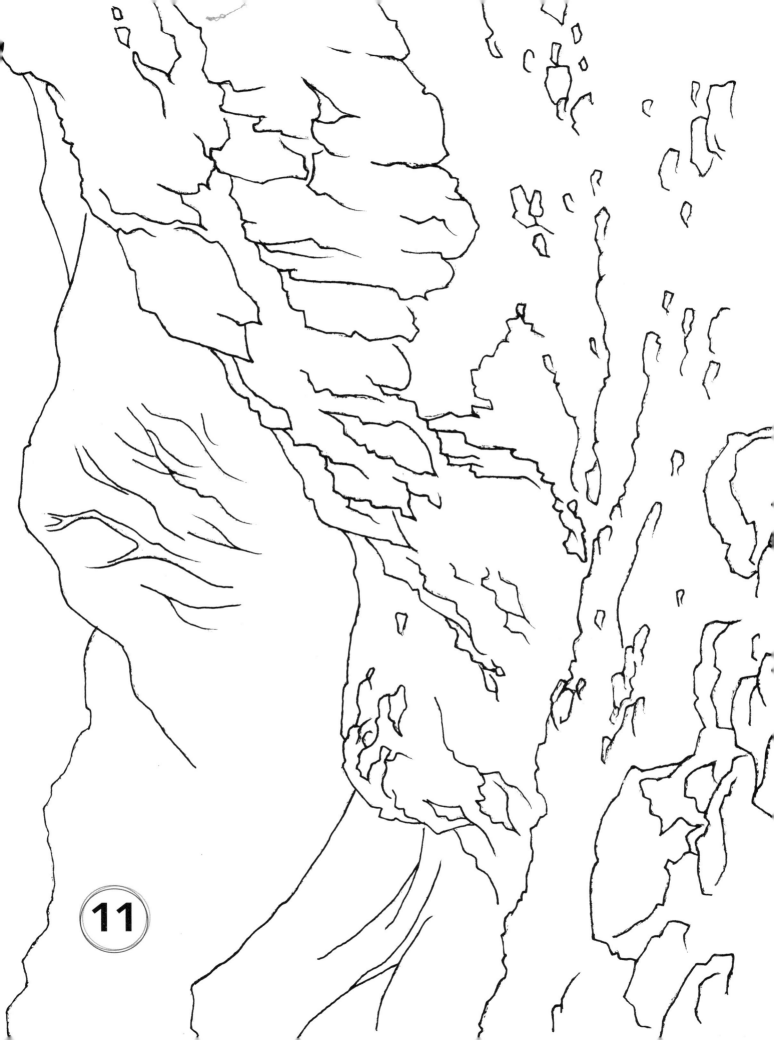

12

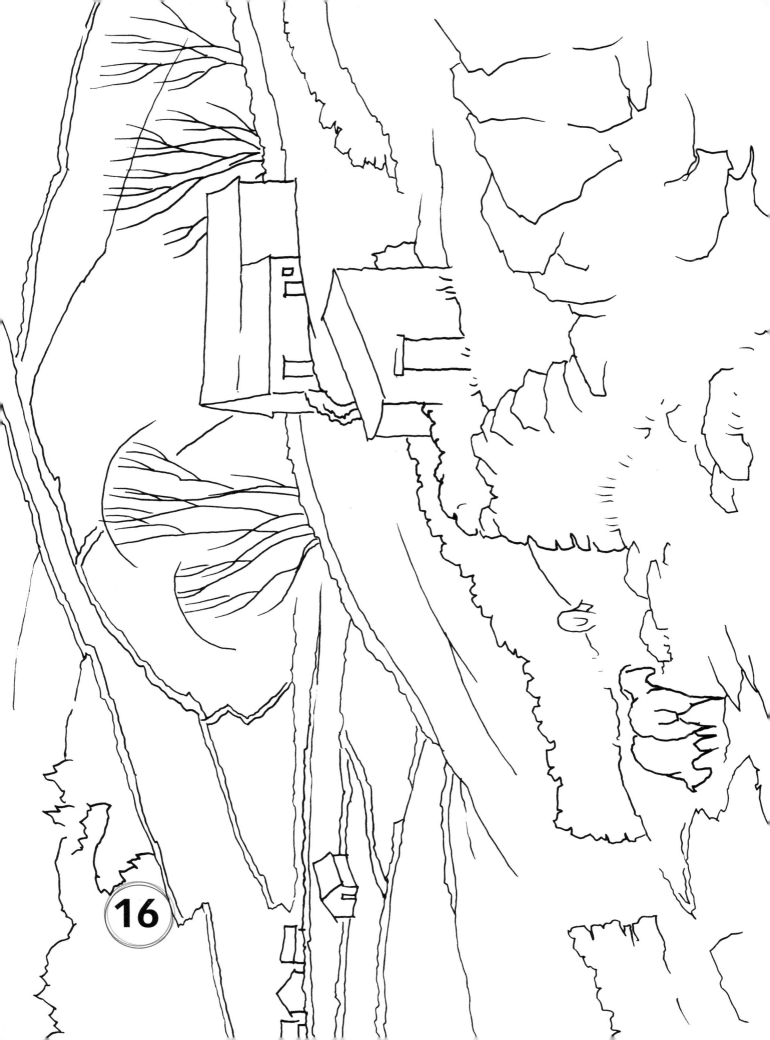

20

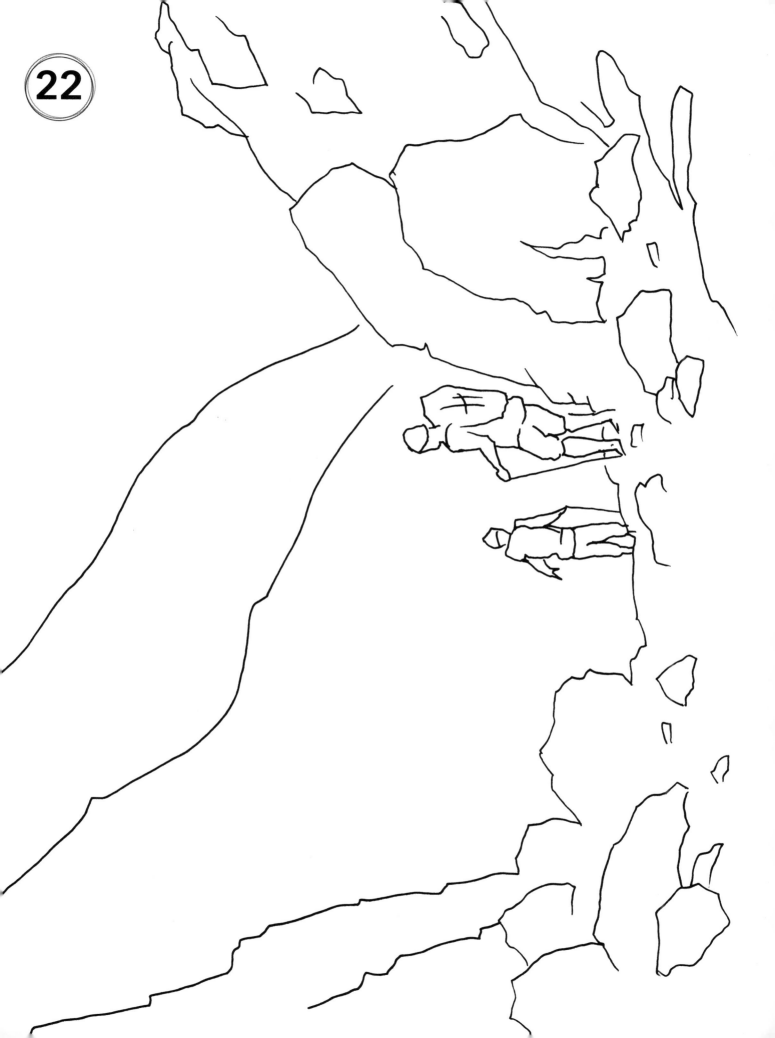

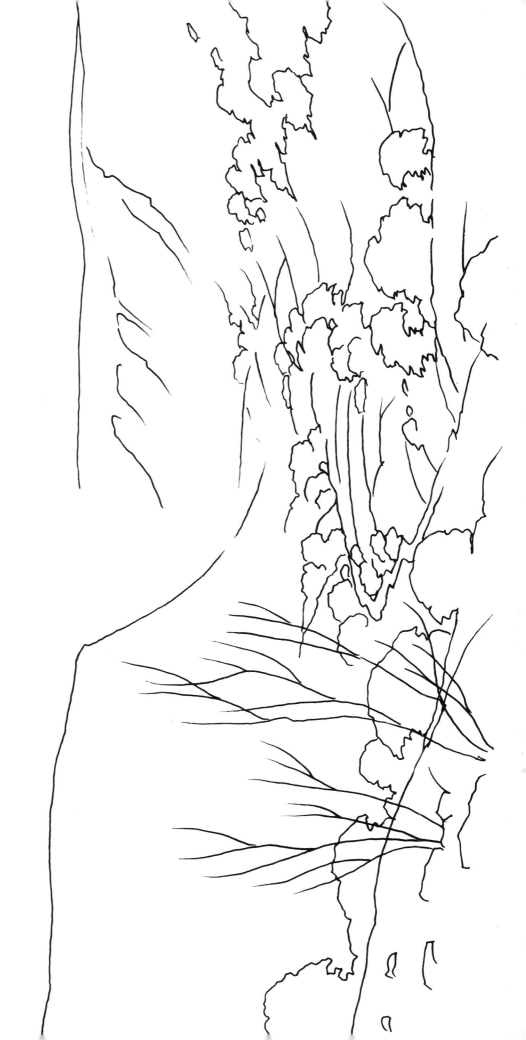